May
2008

Happy 13TH Sam!
Some ideas for the
graduate here - just don't
try pg. 30! xxo Auntie Becca + co.

ODDER JOBS

More
Portraits of
Unusual
Occupations

Odder Jobs

Nancy Rica Schiff

TEN SPEED PRESS
Berkeley | Toronto

Ten Speed Press
Box 7123
Berkeley, California 94707
www.tenspeed.com

Distributed in Australia by Simon and Schuster Australia, in Canada by Ten Speed
Press Canada, in New Zealand by Southern Publishers Group, in South Africa by
Real Books, and in the United Kingdom and Europe by Airlift Book Company.

Cover design by Todd Heughens
Text design by Nancy Austin and Katy Brown

Library of Congress Cataloging-in-Publication Data
Schiff, Nancy Rica.
 Odder jobs : more portraits of unusual occupations / Nancy Rica Schiff.
 p. cm.
 Summary: "A collection of 65 brand-new, gorgeously staged black and
white portraits of people performing their odd jobs, and short
descriptions of their work"--Provided by publisher.
 ISBN-13: 978-1-58008-749-0 (hardcover)
 ISBN-10: 1-58008-749-3 (hardcover)
 1. Portrait photography--United States. 2. Working class--United
States--Portraits. 3. Occupations--United States--Pictorial works.
4. Schiff, Nancy Rica. I. Title.
 TR681.W65S353 2006
 779'.2092--dc22
 2005029669
Printed in China
First printing, 2006

1 2 3 4 5 6 7 8 9 10 — 10 09 08 07 06

Introduction

When I first conceived of a book on odd jobs, I thought I was undertaking a lighthearted project that would enable me to meet unusual people embarked on peculiar life paths. Of course I hoped that the idea—and the images—would resonate with others and tickle their fancy as it did mine. Three years ago, when the first volume, *Odd Jobs*, came out, was I ever in for a surprise! Little had I imagined that it would become an odd sort of career primer, intriguing guidance counselors and being used in classrooms to stimulate discussions of career choices. I understood why when a young librarian from the New York Public Library told me that *Odd Jobs* "inspires creativity." That thought alone sufficed to send me crisscrossing the country again on a second adventure that led me right here—to *Odder Jobs*.

I traveled to Oregon to learn about mushrooms, snowmobiled to the top of Mount Werner in the Colorado Rockies to visit a snow laboratory, and sailed to Little Brewster Island in the Boston Harbor to pay homage to America's oldest lighthouse. I bumped around in a pickup truck in a potentially hazardous graveyard in Texas where no people are buried. I cavorted with muppets on the set of *Sesame Street* and clambered up to three Manhattan rooftops to learn about urban bees. I witnessed three weddings, was invited into the unmarked backroom of a Vegas casino, and gave a lecture to a photo club at a nudist colony.

I encountered people who invented their jobs—discovering a void and filling it with a product or service. Others expanded a favorite hobby into a career. Some were self-taught, others apprenticed, and a number studied for many years to develop their expertise. Several had known what they wanted to be from an early age. Some followed their instincts, some followed their noses, some followed their passions, and others fell into their jobs by chance. By whatever route they got there, these wonderful folks in strange pursuits are blessed indeed: they love their work, and that is the best payment of all.

Leech Purveyor
Garden City, New York

About 650 species of leeches have been named and cataloged. Rudy Rosenberg specializes in *Hirudo medicinalis* (medicinal leeches). They are farm raised and are used to restore veinous blood circulation following cosmetic or reconstructive surgery. The leeches inject an anticoagulant and help dispose of excess blood so it does not go back into the patient's system. Rudy began his career in the biochemical industry, and then shifted from high tech to low when he discovered a market hungry for these little carnivores. He sells the leeches for about $8 apiece. Meeting their quite specific needs, he maintains them in water at 42° to 45°F while they await a patient assignment. Feeding them, however, isn't much of a problem. The leeches are shipped out famished, but these little suckers can go for as long as three years without a bloody meal.

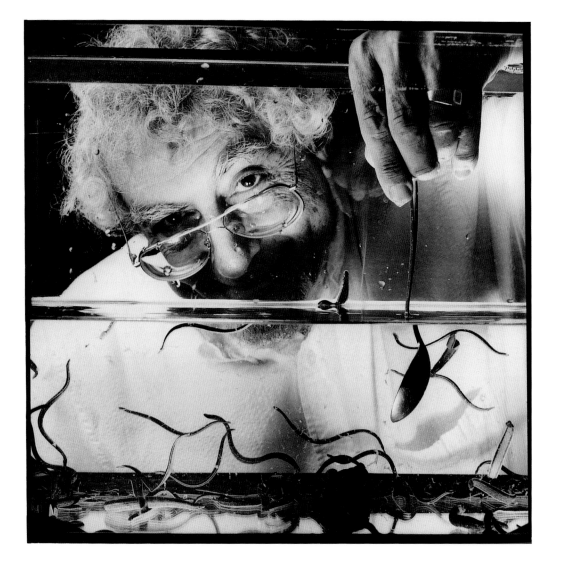

Thereminist
Los Angeles, California

Charlie Lester makes music out of thin air. No strings are attached to his instrument, nor are there keyboards, fingerboards, valves, hammers, or pipes. There is nothing to blow into or onto. But he does use his hands. A theremin's electronic components set up low-power, high-frequency electromagnetic fields around two antennae, one of which controls pitch, the other volume. The player alters the fields—and the resulting sounds—by moving his hands closer to or farther from the antennae. Like the mode of playing, the music produced is eerie and otherworldly, which inspired its frequent use in early suspense films. Charlie was first drawn to the instrument when he saw a film about its inventor, Leon Theremin, a Russian physicist who created the theremin in 1918. A self-taught and left-handed thereminist, Charlie has taken the instrument to new heights, performing for the dedication of the Disney Music Hall in Los Angeles as well as in several TV commercials and the movie *Monster Makers*.

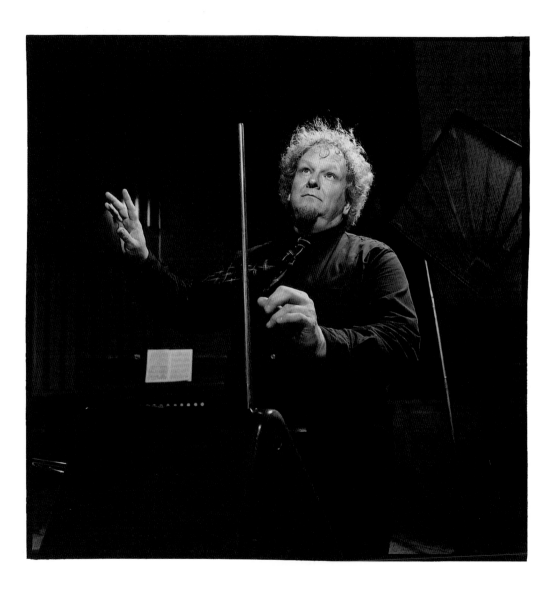

● Pollen Collector
Spokane, Washington

From March through September, Anne Schrempp spends a good part of her time on a 16-foot ladder in Spokane's treetops. But no apples or cherries for her. She harvests the pollen-laden male sex organs (anthers) from the blossoms of forty-one types of trees, including red oak, sugar maple, golden acacia, and paper birch. When she is down on the ground, Anne is busy with a vacuum cleaner, sucking up samples of such wind-pollinated mischief makers as Bermuda and Kentucky bluegrass and weeds like Russian thistle and lamb's-quarter. Once gathered, she delivers this bounty to a lab, where it is carefully laid out to dry on clean racks. Eventually it passes through a series of sieves, emerging as 100 percent pure pollen extracts. Anne's employer, Hollister-Stier Laboratories LLC, produces thirty-six tree pollen extracts, twenty-two weed extracts, and eighteen grass extracts that, come springtime, make all the difference in the world to allergy sufferers.

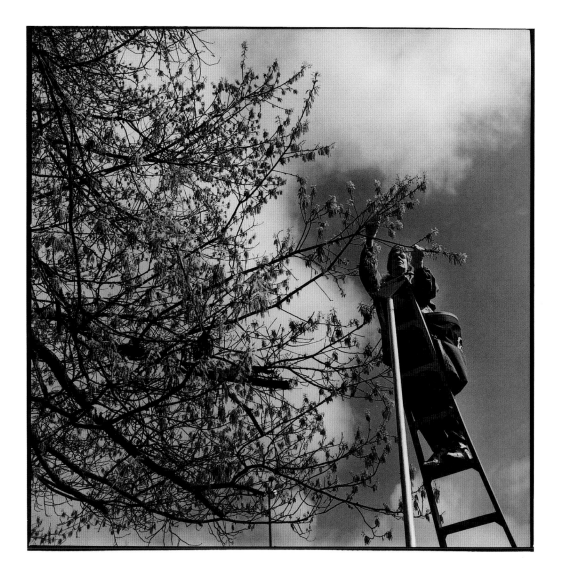

Turtle Rescuer
South Padre Island, Texas

Jeff George began working at Sea Turtle, Inc., as a volunteer, but he took over the helm of the nonprofit turtle rescue center in 2000 when its founder, Ila Loetscher, known as the Turtle Lady of South Padre Island, died. Now Jeff, a former steel manager from Pennsylvania, is en route to becoming the island's Turtle Man. Jeff's mission—and the center's—is to care for rescued and injured sea turtles, educate the public about them, and promote sea turtle conservation programs the world over. There's an element of urgency in the endeavor, as all seven sea turtle species (five of which are found on South Padre Island) are now either endangered or threatened. Other than the center's single permanent resident, a 200-pound loggerhead, almost all the turtles convalescing at Sea Turtle, Inc., are eventually released back to sea. But before returning home, they go through a ritual of being weighed, tagged, and identified with a microchip. Last year, some thirty-eight thousand tourists visited the inhabitants of Sea Turtle, Inc. Were it not for Jeff George, future generations might not have that opportunity.

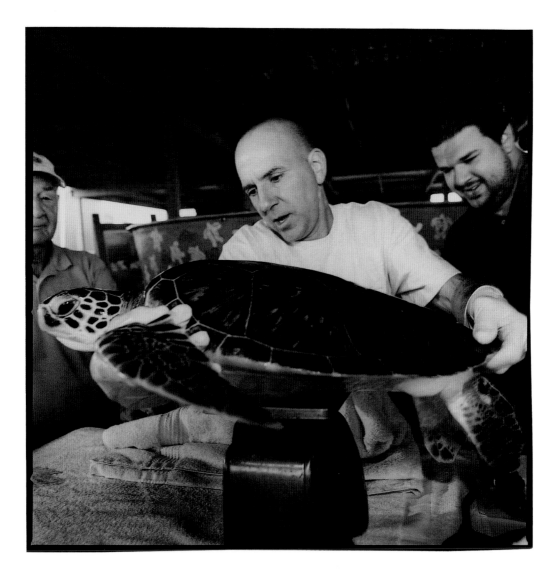

Elvis Minister
Las Vegas, Nevada

Weddings are the stuff of fantasies, and nowhere more so than in Las Vegas. Whether a bride and groom prefer to say their "I do's" before Elvis, Dracula, King Tut, Austin Powers, John Travolta, or the Godfather himself, Ron DeCar of the Viva Las Vegas Wedding Chapel can satisfy their wishes in any of these guises. DeCar does a particularly fabulous Elvis impersonation, performing the ceremony with song—and an authorized minister as backup. The most popular dates for weddings at the chapel are Valentine's Day, which generally logs in about one hundred and fifty blissful couples; Halloween, with fifty to sixty weddings; and New Year's Day, with, so far, a high score of forty ceremonies. A leap year, 2004, provided DeCar with a bonus day. Though their anniversaries will be few and far between, sixty couples tied the knot that day—thirteen of them to the King of Rock 'n Roll's "Can't Help Falling in Love with You."

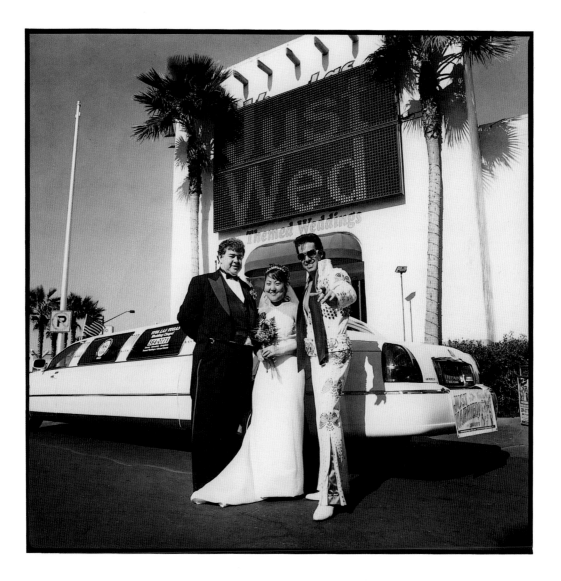

Snow Researcher
Steamboat Springs, Colorado

Working at an altitude of 10,525 feet in a laboratory perched on the west summit of Mount Werner, Colorado, Dr. Randy Borys literally has his head in the clouds, which is mighty useful for this Storm Peak Laboratory snow researcher. As an observationalist, Randy collects snow and analyzes its content. Notwithstanding the elaborate equipment in his lab, he's been known to venture forth simply with a black velvet–covered board and a magnifying glass. For the past ten years, he's been studying the effect of pollution on snowfall by analyzing ice crystals. Unfortunately, his findings are discouraging. With the yearly rise in pollution, Colorado snowfall, which contributes significantly to the water supply for the western states, has been decreasing steadily. In other words, we better clean up our act.

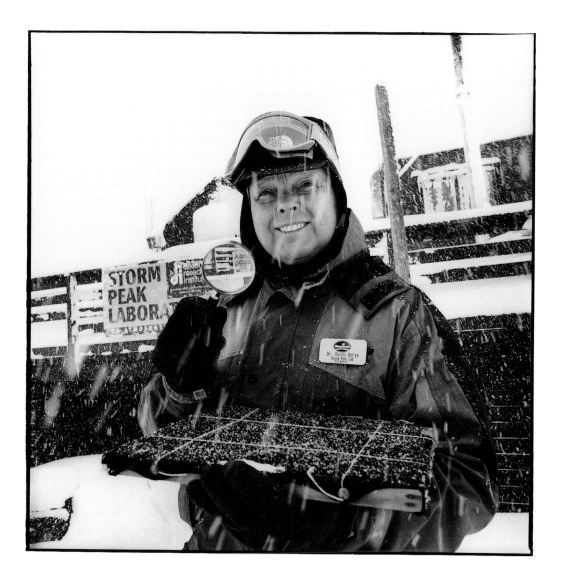

Breath Odor Evaluator
Canton, Massachusetts

For Barbara Abbot, the nose knows. An odor judge at Shuster Labs, the smells of her success have rarely been sweet. To test the merits of products such as mouthwash or breath mints, she takes deep whiffs of pungent morning breath or breath "insulted" with coffee, cigars, garlic, or onions. She then rates the breath on a scale from one to nine, one for the most malodorous and nine for the least. Ideally, after a panelist has used the product being tested, Barbara's nostrils get a break. To perform a test, a panelist exhales into a tube on one side of a wall; on the other side, the tube penetrates a cup covered with a thin cloth. This is what Barbara sniffs. The American Society for Testing and Materials sets screening criteria guidelines for odor judges. Panelists are always nameless, identified only by a three-digit number. She helps test about two thousand products a year. The worst odor Barbara has ever tested? No contest: dirty socks.

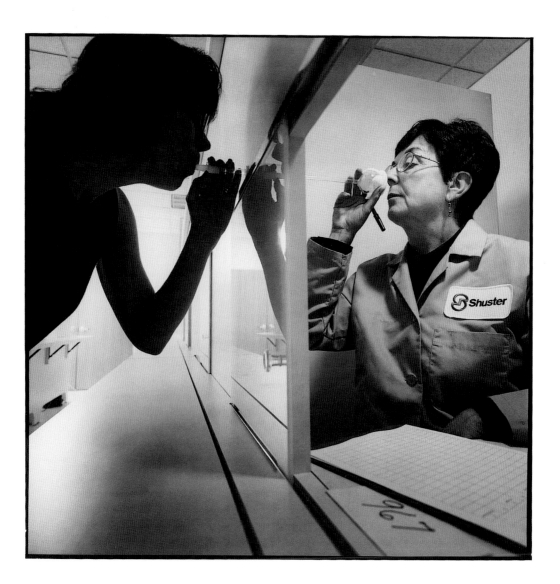

Canine Massage Practitioner
Santa Fe, New Mexico

If man's best friend has an ache, a visit from Kristen Miller may be just the ticket. Miller has a massage table and will travel. A veterinarian technician for six years, she went into business for herself two years ago and now offers canine massage, nutrition, and exercise programs. She specializes in geriatric dogs with arthritis, those with hip or elbow dysplasia, and those recovering from surgery. Shoulders, hips, and backs are frequent sore spots for dogs, she claims, and bending too far down to eat often causes neck problems. To train for her work, Miller enrolled in a 682-hour program, the same time required to obtain a human massage therapist license.

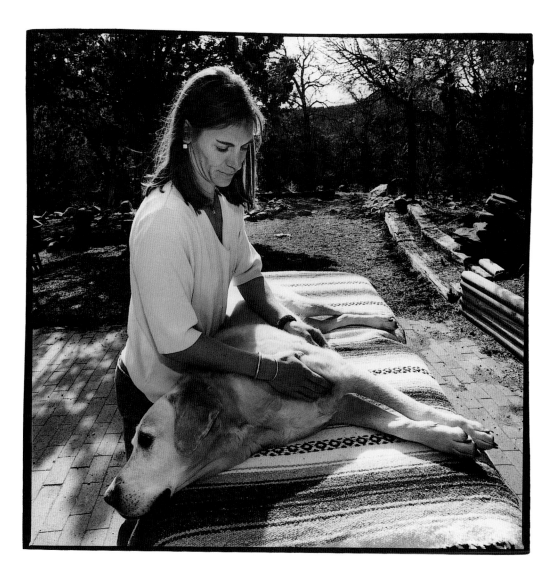

Rubber Chicken Maker
Salt Lake City, Utah

With a catalog of more than a thousand gag items, Gene Rose can boast that rubber chickens have helped make him a millionaire. He's been selling them all over the United States for the past twenty-five years. No one can explain the rubber chicken's great appeal—least of all Mr. Rose—but he gives credit to Johnny Carson and *The Tonight Show* for helping to popularize his prize poultry. Having launched his career as owner of a magic shop at age seventeen, Mr. Rose, now an octogenarian, has demonstrated that with the right product, and a bit of luck, anyone can hit the jackpot.

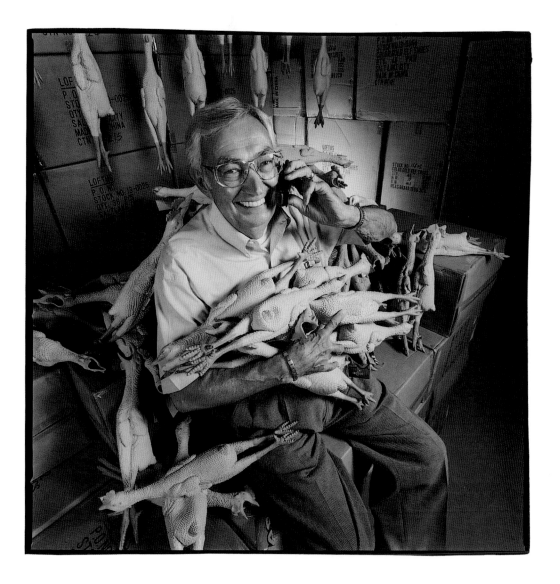

Elmo Muppeteer
New York, New York

As one of fifteen core muppeteers on *Sesame Street*, Kevin Clash is one of the most popular when he brings the character Elmo to life. Kevin isn't the first muppeteer to play Elmo, but he's the one who added the trademark falsetto voice and the sweet, curious worldview that make the character so well-loved by both young and old. Kevin admits that Elmo, with the psychological age of a three-and-a-half-year-old, is very like the kid he was, which makes ad-libbing the part easy for him. A fan of *Sesame Street* since childhood, Kevin began building puppets at age ten and was performing on Baltimore's Harbor Front in his teens. In 1979, he began working on national television shows, including *The Great Space Coaster* and *Captain Kangaroo*. Attracting the attention of muppet designer Kermit Love, he was invited to join the *Sesame Street* cast, where he has also put his stamp on Hoots the Owl, Baby Natasha, and Benny the Bunny. In addition to muppeteering, Kevin spends part of each year scouting for new talent—on the lookout for promising muppet wannabes.

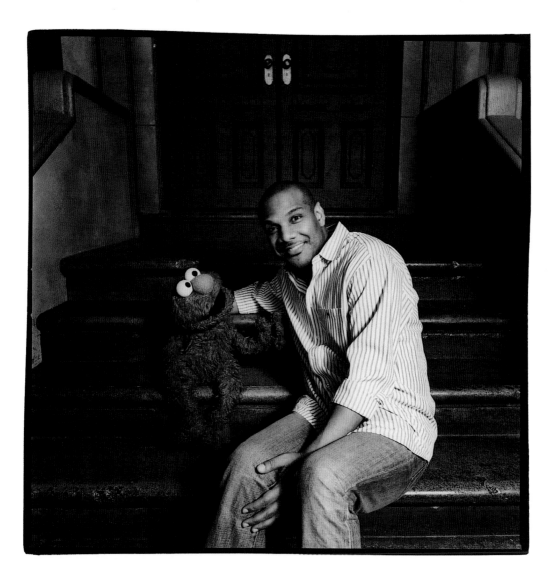

Paleoscatologist
Boulder, Colorado

Examining dinosaur dung isn't everyone's cup of tea, but it exerts a strong pull on Dr. Karen Chin. An expert in her field, she's even written a kid's book on the subject called *Dino Dung*. Inspired by famed paleontologist Jack Horner, who has discovered many dinosaur fossils, Dr. Chin took up the study of fossilized feces, known in her trade as coprolites. In her lab at the University of Colorado at Boulder, she studies the exterior of her samples with a microscope, then slices off thin slivers to see what's inside. It turns out that coprolites, some of which date back 400 million years, contain traces of dietary residues—what ancient animals ate for dinner. She has identified bones, seeds, shells, leaves, wood, microscopic marine life, and even fossilized meat in different specimens. Coprolites have been found on every continent, and Dr. Chin has gone as far as the Arctic in quest of them. Happily for her, coprolites are a fertile way of looking into the past; they offer as much info about ancient ecosystems as dino bones do.

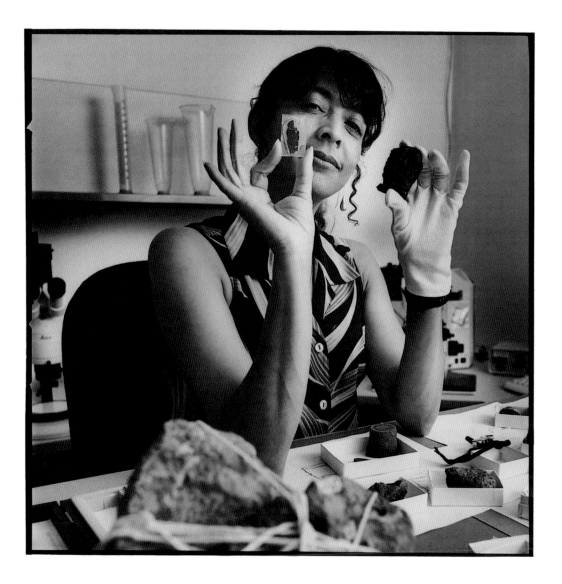

Farrier
Ossining, New York

Proper-fitting shoes are every bit as important for horses as for humans, believes farrier Peter Taraba. As every hoof is unique, every horseshoe has to be individually shaped. Having grown up around horses, Taraba knows the right shoe can prevent a host of problems. He spends a good part of his time on the road in a truck custom-fitted with the tools of his trade, making the rounds of thirty-five stables in his tristate area. In the summer, Taraba visits his equine clients every four or five weeks to fit them with new shoes. In the winter, he returns every six or seven weeks to trim and maintain their hoofwear. The final affixing of a horseshoe is appropriately called the "clincher." Taraba's deft hands and calm demeanor keep his charges at ease.

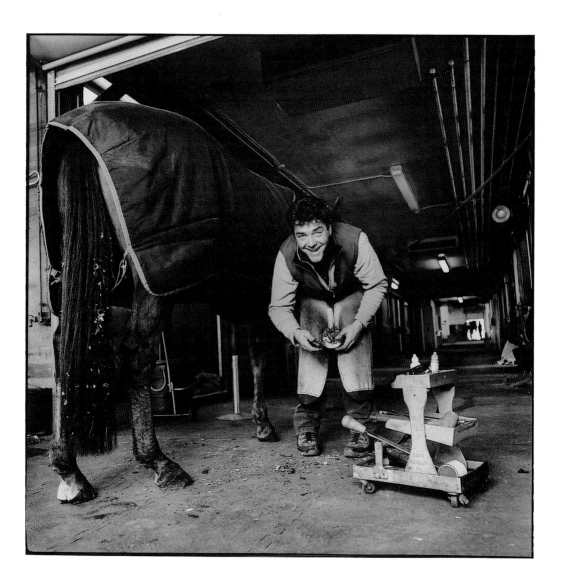

Men's Underwear Designer
New York, New York

Originally a designer of men's ties, Jennifer Fischetti spent twenty years working in various facets of menswear before getting down to their underwear. Once there, she quickly realized she had some serious design challenges ahead. With today's men being so fashion conscious, the long-time favorite—tighty whiteys—have some real competition. As vice president of men's underwear at Nautica, she designs new fits, such as the trunk, and works with new synthetic fabrics, but, as always, comfort takes top priority. Jennifer is forced to get up pretty close and personal to some hunky fit models, making certain they're comfortable both fore and aft.

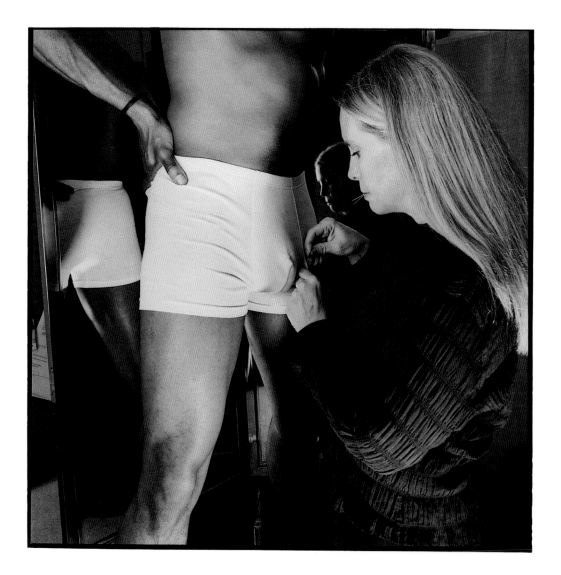

Hypervelocity Gunner
Las Cruces, New Mexico

Speed is of the essence for Paul Mirabal, one of two eagle-eyed, steady-handed gunners at NASA's hypervelocity testing site. More than 450 times a year, he and his colleague run tests with seven-, seventeen-, thirty-, and fifty-caliber guns, and with the meanest gun of all—a one-incher with an 80-foot-long pump, a 24-foot-long barrel, and a total length of about 200 feet. These big kahunas use gunpowder—several pounds of it per shot—to accelerate a piston that compresses hydrogen gas, which drives a projectile of aluminum, glass, sapphire, nylon, or steel down the barrel. Optical and X-ray cameras monitoring the guns clock velocities of about sixteen thousand miles an hour and take pictures of the projectiles in flight. The purpose of all this fancy shooting is to test the effectiveness of the shields that protect our spacecraft from debris and micrometeorites.

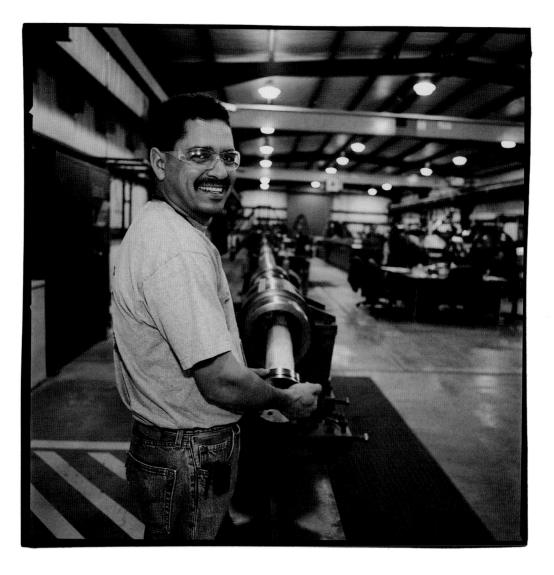

Rubber Tire Graveyard Security Guard
Atlanta, Texas

No one knows better than Jim Horne the dangers that lurk in the
man-made, rubber hills of Atlanta, Texas. Piled up to thirty feet
high in an area measuring two and a half miles around its perimeter
are as many as two million worn-out rubber tires. Rusting away
and building pressure from their accumulated weight, the tires also
generate considerable heat—on a hot day rising to as much as 160°F at the
surface of the mounds. The danger is spontaneous combustion, and
Jim and his security force, Horne Enterprises, Inc., are at the ready to
call the local fire department should such a conflagration occur. The
fate of these tires? Some 60 percent will ultimately be recycled. Mixed
with asphalt, they'll be shipped out of state and used for resurfacing
roads. The remaining tires will be quartered and buried on site.

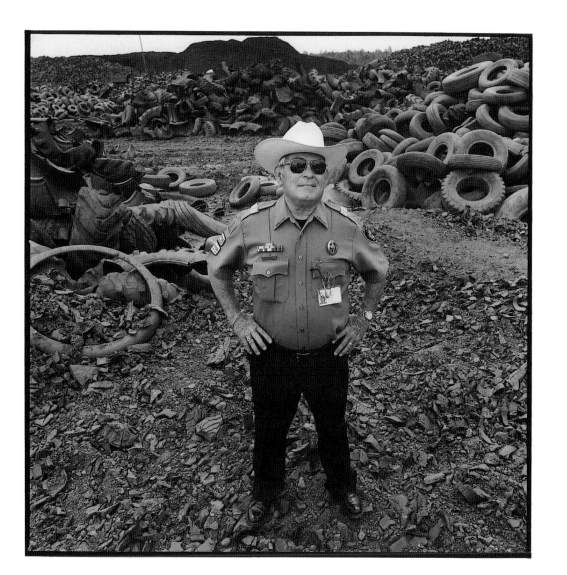

Wig Maker
Canadensis, Pennsylvania

No, Bettie Rogers is not the Bearded Lady, but she has been known to don a beard or a mustache. Call it a perk; Bettie creates wigs, beards, mustaches, toupees, muttonchops, and even eyebrows and chest hair. Bettie apprenticed as a wig maker at the Santa Fe Opera before going to New York City to build wigs for the Broadway show *Swinging on a Star*. She still makes wigs for theater, television, and film, but her clientele now also includes cancer patients and other hair loss sufferers. To build a wig, Bettie first creates a plastic model of the head and hairline, using plastic bags and invisible tape. She then transfers the shape onto a padded canvas block that corresponds to the person's general head size and makes a cap from wig lace to fit the plastic model. Next begins the time-consuming part—adding ventilation. Using a needle that resembles a crochet hook, one by one, she knots and pulls thousands and thousands of hairs through the mesh cap. Bettie has spent fifty hours ventilating a single wig. Once the hairs are in place, Bettie styles it according to the wearer's preference. She's done it all—from Mohawk to beehive.

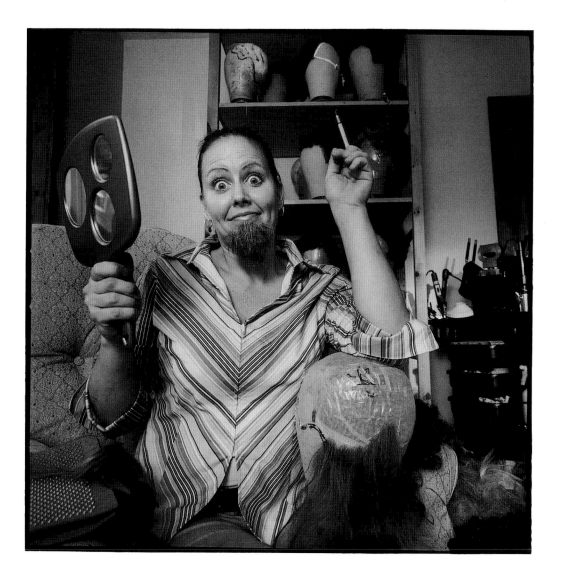

Face Feeler
Manhattan, Kansas

It wouldn't surprise Anice Robel to be called a touchy-feely kind of person, or someone with a sensitive touch. For the past twenty-two years, Anice has worked at the Sensory Analysis Center at Kansas State University, touching and feeling a variety of textures, from automobile seats to shampooed and conditioned hair to toothbrushes, which she's tested on her own teeth and gums. For Anice, a typical day's work as a face feeler might entail testing the effectiveness of razor blades by evaluating the closeness of shave they produce. To this end, she lets her fingers do the walking—over the faces of a panel of male subjects. She strokes their cheeks, under their noses, and under their chins. And because textures are hard to describe objectively, she equates the feel of their post-shave epidermis with a grade of sandpaper, from fine to coarse. After each feel, she washes her hands, just as a wine taster cleanses his palate between sips.

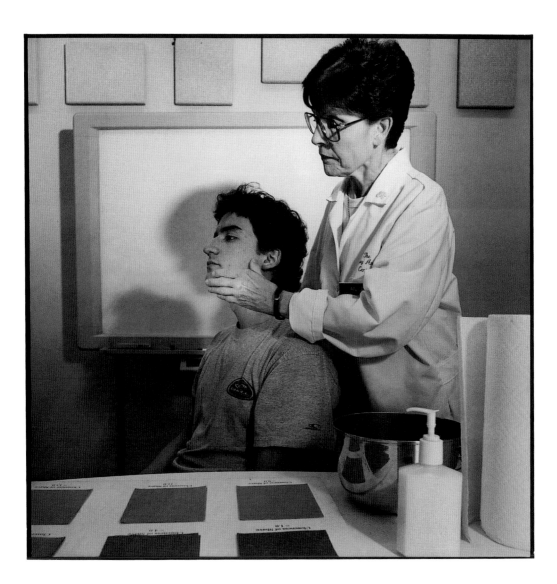

Fish Doctor
Shirley, New York

For years, Dr. Julius Tepper's veterinary practice revolved around dogs and cats. But one day, when confronted with a sickly koi, Dr. Tepper strayed. At the time, fish specialists were few and far between, making his pursuit of piscine medicine pioneer work. He'd been a fish enthusiast since boyhood, keeping aquariums and studying pond life, so he was able to teach himself what he needed to know. As a fish practitioner, one of the first things he does is check for parasites, which can be found internally or externally. Because a fish's watery environment plays a huge part in its health, the study of water quality is frequently part of the doctor's diagnosis. Fortunately, in fish as in humans, bacterial diseases respond to antibiotics—a series of injections in the belly can do wonders. Again, like humans, fish are what they eat, and Dr. Tepper treats many cases of obesity. His advice to people who overfeed their pet fish: don't kill 'em with kindness.

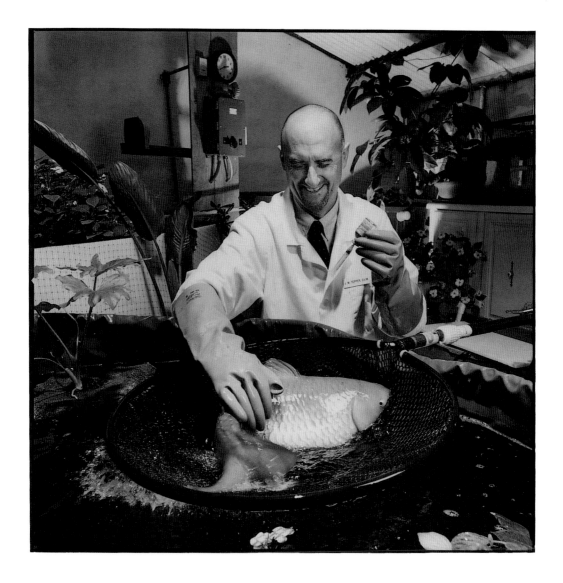

Gross Stunt Producer
Los Angeles, California

Once a week, Scott Larsen sets out to prove that one man's meat is another man's poison. Having begun his tenure in Hollywood working in casting, he now spends his days searching for ways to gross out contestants on the TV reality show *Fear Factor*. As gross stunt producer, it's his job to entertain an audience of twelve to fourteen million viewers weekly by inventing stomach-turning feats for the fearless. Although in some parts of the world cows' intestines, millipedes, hissing cockroaches, horse lubber grasshoppers, pig snouts, and tarantulas are considered tasty treats, none of *Fear Factor*'s intrepid contestants has ever requested a second helping.

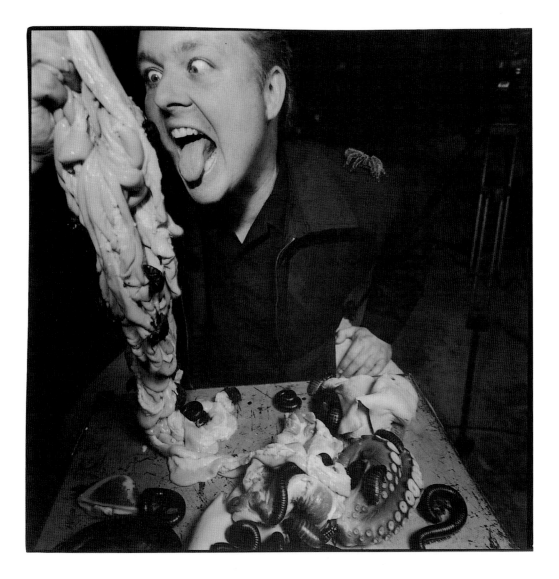

Mermaid
Weeki Wachee, Florida

Twice a day at Weeki Wachee Springs, Sativa Smith leaves her audience breathless by performing Hans Christian Anderson's fairytale, *The Little Mermaid*. It takes about three months to learn to be a mermaid. During the show, Sativa swims in 72°F springwater for forty-five minutes, all the while smiling and lip-synching—and either holding her breath for up to two and a half minutes or breathing from an underwater air hose. The Mermaid Theater dates back to 1947, when the first underwater show was presented at the newly built Mermaid Park. Located about fifty miles north of Tampa, the future of the mermaids at Weeki Wachee Springs is uncertain due to the decreasing number of visitors. In the meantime, Sativa soaks up the glory from the little mermaid hopefuls who swarm around her after each show.

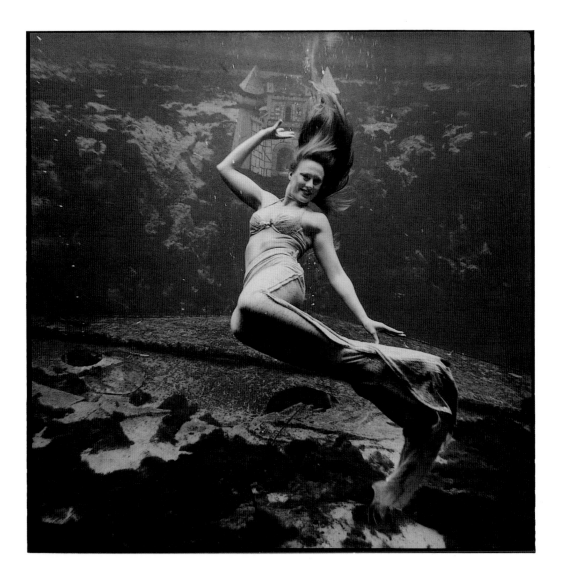

Casino Surveillance Person
Las Vegas, Nevada

The hand may be quicker than the eye, but Michael Craig wouldn't bet on it. A casino surveillance worker, he has been people watching for the past eleven years from an undisclosed post at Harrah's. Craig's practiced eyes are on the lookout for anything irregular. He and his coworkers monitor six hundred cameras that are located throughout the hotel. Should he want to, he can zoom in close enough to even read the dial on a gambler's wristwatch. No detail is too small to notice or to videotape. Surveillance people work eight-hour shifts, producing some two hundred videotapes per shift. Miscreants beware: these tapes are stored for several years so suspicious behavior can be traced backward or forward.

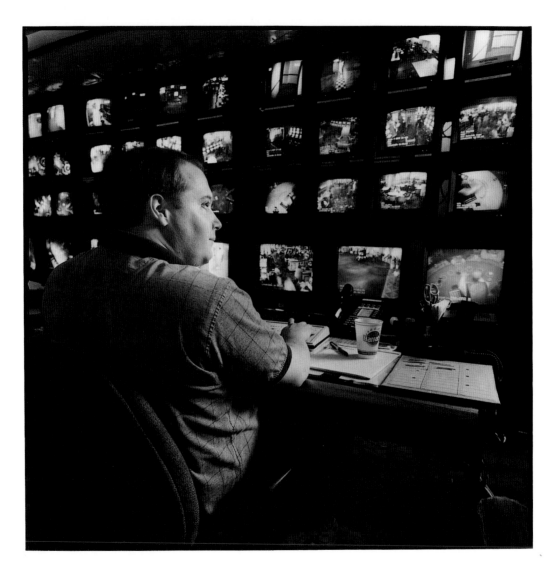

● Product Performance Evaluator
Canton, Massachusetts

In a room at Shuster Labs that's affectionately known as Flushing Place, Jim Hammer puts his knowledge of chemistry to work testing toilet water (the real stuff), evaluating cleansers, and formulating new cleaning products and methods for testing them. If a cleansing product is claimed to be good for two thousand flushes, it's Jim's job to verify the claim. Putting a product through its paces, he checks its color retention, its effect on hard water residue, and—last but most important—its effect on organic soiling. For testing purposes, toilets are subjected to some pretty nasty stuff. They may be smeared with fish emulsion-like soils above the waterline or with organic compounds made of cat food and cow manure. Jim's test toilets are programmed to flush automatically ten times a day to simulate normal flushing in an average household. Fortunately, it doesn't bother him to see his efforts go down the drain.

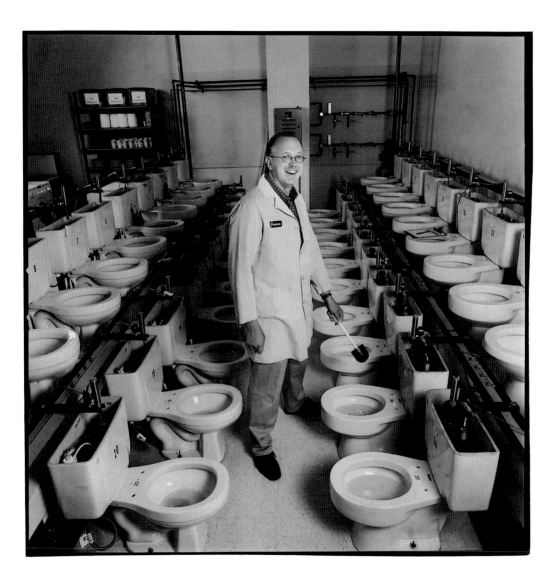

● Whisky Ambassador
New York, New York

In 1990, Jeremy Bell closed the books on a career in accounting and aptly cracked open a bottle of whisky to toast his new direction. After a stint in journalism as a whisky journalist for *Decanter Wine Magazine*, he went on to present whisky tastings. The Glenlivet company tapped him in 1993 to become Brand Ambassador for their whiskies. Now Jeremy travels the country, attending eighty tastings a year for the "This Is the Chivas Life" tour. To get his typical audience into the spirit of things, Bell dons a kilt and plays the bagpipes. With gusto, he offers the group a crash course in Scotch 101, wetting their whistles with a Chivas cocktail, and then talking them through five different whisky tastings. Explaining the subtleties of scotch, he illuminates the differences between single malts and blends and illustrates how whisky should be served, sipped, and savored. Bell likes to say that he got out of the accountancy abyss and into beverage bliss.

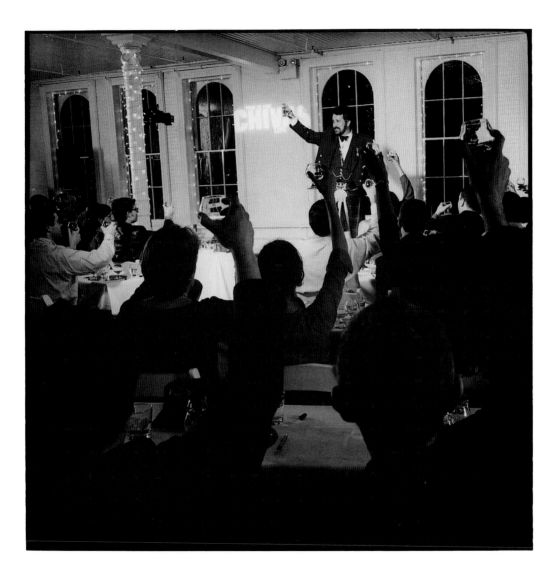

Dog Food Tester
Manhattan, Kansas

Dog-food testing is not for the squeamish, because the best way to test it, claims Patricia Patterson, is to taste it. At the Sensory Analysis Center on the campus of Kansas State University, she analyzes samples of dog food for flavor, of course, but also for texture. Typically, dog owners don't like dog foods that make lots of crumbs. Patricia may conduct a test in which she compares the hard texture of a mini steak-shaped dog biscuit to seven very different human food samples: cream cheese, hard cheese, egg white, olives, frankfurters, nuts, and candy. Occasionally, she may be called on to test a competitor's product. If, for example, another dog food manufacturer claims that their product is beefier, Patricia will have the final word on where's the beef.

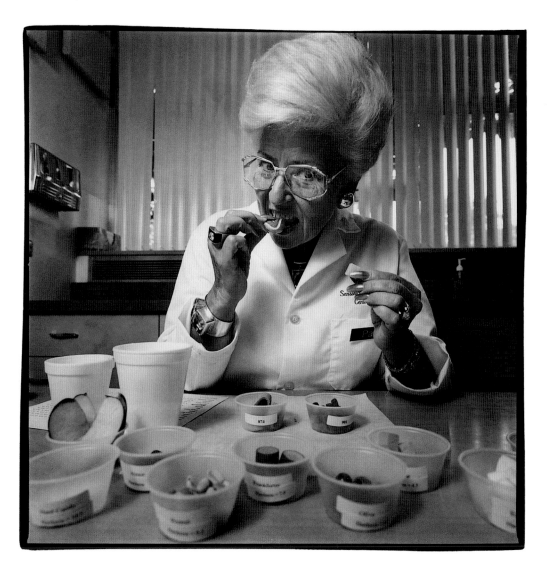

Bonfire Builder
South Padre Island, Texas

Dennis Barrett is famous on South Padre Island for the bonfires that he's been burning on local beaches for the past three years. He's built them for company parties, boat races, and a Miss Teen America pageant. He bids his jobs based on the amount of wood required. A typical job might require two 16-foot flatbed trailer loads of wood—enough to last for five hours. Generally, it takes Barrett several days to accumulate sufficient wood for a bonfire. He gathers wood from several sources, including driftwood that washes ashore on the island's beaches and construction scrap supplied by friendly carpenters. His favorite material is tree trimmings from the local recycling center. Barrett starts a fire by igniting oil-soaked paper towels with a propane torch. Then he gradually feeds wood into the fire, controlling its progress like a conductor, timing the crescendo just so—often with the sunset, for high drama.

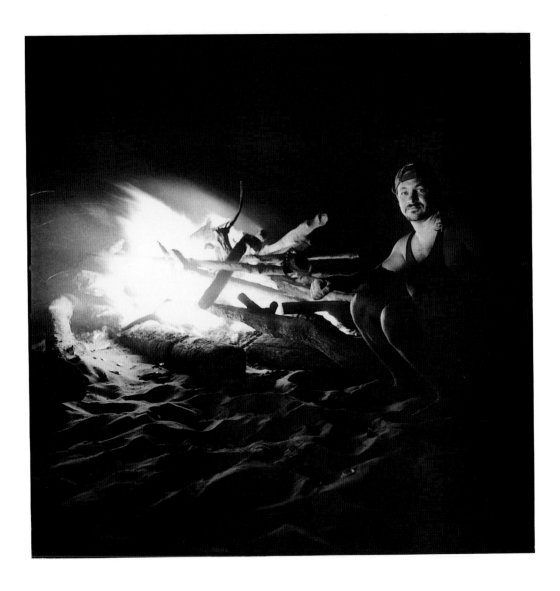

Horse Chiropractor
La Quinta, California

As Corrine Morrison was finishing her exams for practicing chiropractic on humans, she decided to go on for an additional year and a half to obtain a license to work on animals. Where she lives in the California desert, her animal clients include many polo ponies, which usually have neck problems due to the fast turns they are forced to make during polo games. Hunter jumper horses often have hind end problems, and dressage horses get jammed up all over because they are made to go sideways. When she works on horses, she has to be attentive to avoid kicks, bites, and sudden reactions the animals may make to noises that scare them. Corrine likes to divide her practice between humans and animals, which means using very different muscles of her own.

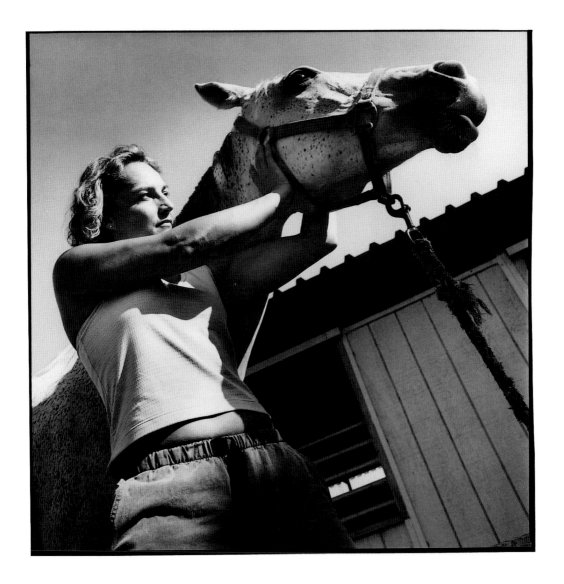

Venom Sac Extractor
Spokane, Washington

Honeybees, hornets, yellow jackets, paper wasps, and fire ants—having worked at Hollister-Stier Laboratories for the past fifteen years, Maria Campbell knows them all, inside and out. Because venom can cause severe allergic reactions, the poisons extracted from them are used for diagnosis and immunotherapy. Bees arrive at the lab frozen in bags. Using a sharp pair of tweezers and magnifiers, Maria spends about an hour and a half completing work on a single bag, which contains 300 to 500 bees. After the poison extraction, each body is discarded, and the venom is sterile filtered and freeze-dried in bulk form until it's compounded for final use. In this sting operation, Maria is known by her colleagues as the Queen Bee.

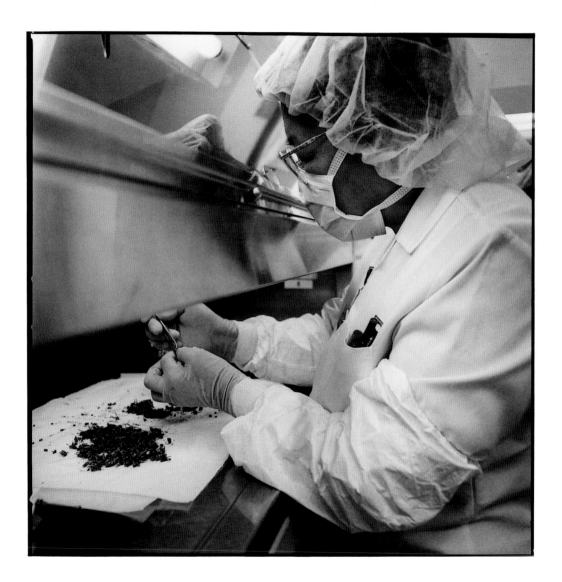

Naturist Club Owner
Los Gatos, California

Ed Dennis wears many hats—but not much else. Ed worked for some time as general manager at the Lupin Naturist Club. Now, he's purchased the spread and continues to manage it. His acquisition wasn't fueled by naked ambition, but rather by Ed's longtime fondness for life in the buff. As for Lupin, which was established in 1936 and is currently the oldest member of the Los Gatos Chamber of Commerce, the real estate slogan "location, location, location" fits it to a T. Situated amid an evergreen-studded 110 acres in Northern California, this family-oriented, clothing-optional facility enjoys a unique microclimate averaging three hundred sunny days a year. What more could anyone devoted to alfresco relaxing hope for—except maybe sunscreen.

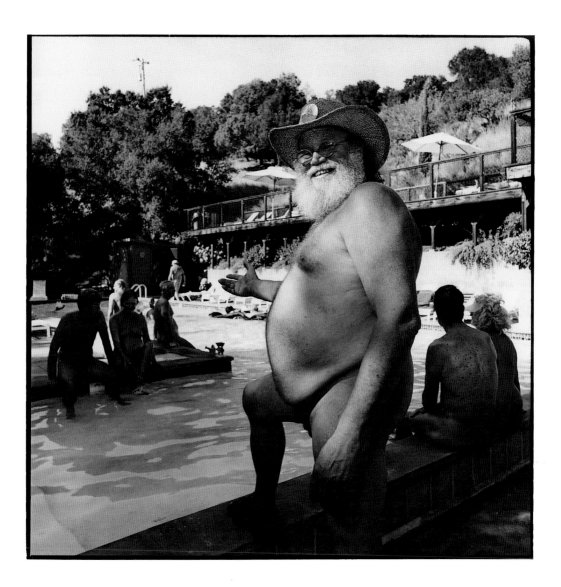

Sign Painter
New York, New York

As one of the breed of sign painters now all but extinct, Alberto Gonzales has spent the last thirty-one years employed by Artkraft Strauss, the oldest billboard sign maker in New York City. Alberto has worked on a 200-foot high, 94-foot wide side of a building, such as at the corner of Thirty-Fifth Street and Eighth Avenue. Starting with a sketch that he duplicates to scale on his enormous canvas, Alberto on average spends two and a half months painting a billboard. Although he's generally a modest man, there's nothing idle in his boast that millions see his work every day.

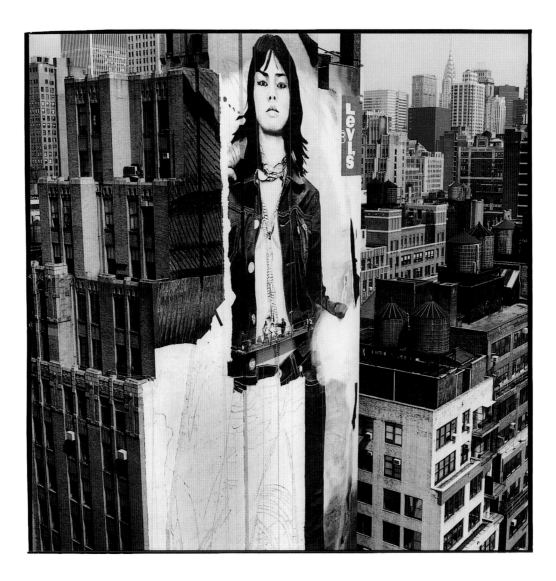

Yo-Yo Tester
Euless, Texas

A fad item that has had its ups and downs, the yo-yo appeared in the United States around the time of the Civil War and has been rediscovered by every generation since. For the past three years, Ginger Miller has been building as many as one hundred yo-yos a day for Spintastics, and to test them she throws every single one. Ginger reports that yo-yos today sell for anywhere from $6 to $150. The most expensive are either custom-made or antique. Price often relates to complexity. Spintastics makes about a dozen models; the simplest is composed of six parts and a cotton string, and the fanciest is made of fourteen components and a strong polyester string. Ball bearings are a modern addition that make yo-yos faster and give them greater spin. "Technology has set in," claims Ginger. Even the names of today's tricks have a new spin on them. Remember Walk the Dog and Sleeper? How about Split the Atom, Warp Drive, UFO, Gravity Pull, or Mach 5?

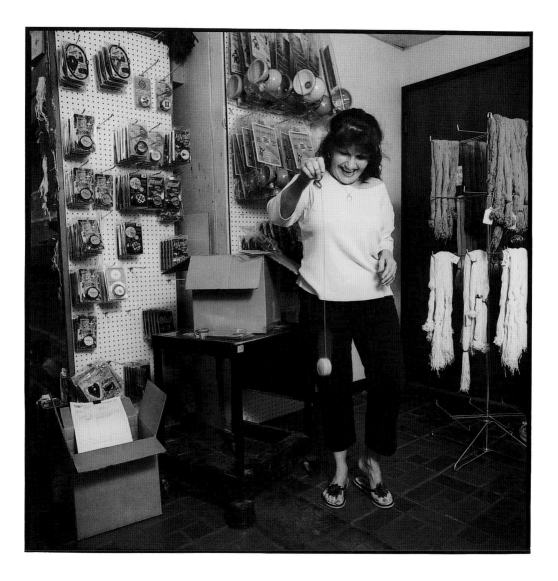

Dice Inspector
Las Vegas, Nevada

Although not a gambling man, Bob Boehmer is more familiar with dice than the slickest craps shooter. Employed by the Nevada Gaming Board, which randomly collects dice from the craps tables in Las Vegas, Bob has the job of inspecting them. First he checks to make sure that they are not misspotted. If the four is on one side, there must be a three directly opposite; the numbers on opposite sides must always add up to seven. Bob checks the dice for right angles, for correct spin, and for calibration, making sure that all sides are identical in size. With twenty years of service under his belt, Bob remembers only one case of crooked dice.

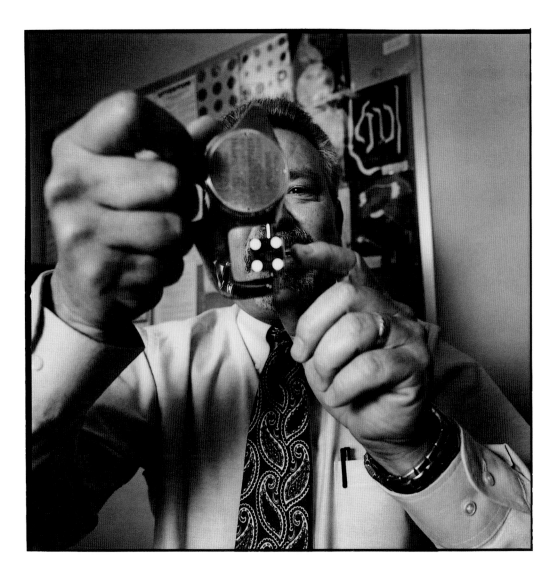

Alligator Skinner
Christmas, Florida

There's only one way to skin an alligator, and that's very carefully. A single slip of the knife can bring down the value of the skin by 25 percent. Melissa Yates would know. She's been skinning gators for the better part of ten years. A small one takes her about fifteen minutes to skin, a large one a couple of hours. Because farmed alligators are never allowed to reach maturity, eggs are brought in from the wild. When the gators reach five to six feet, they are harvested, skinned, cleaned, dried, salted, and refrigerated. The meat is processed for human consumption. Froelich's Gator Farms, where Melissa works, is home to some three thousand gators at any one time. Some really big gators—considered nuisance alligators—are brought in when captured by local state trappers. Their large skins are coveted for elegant luggage and other large luxury items.

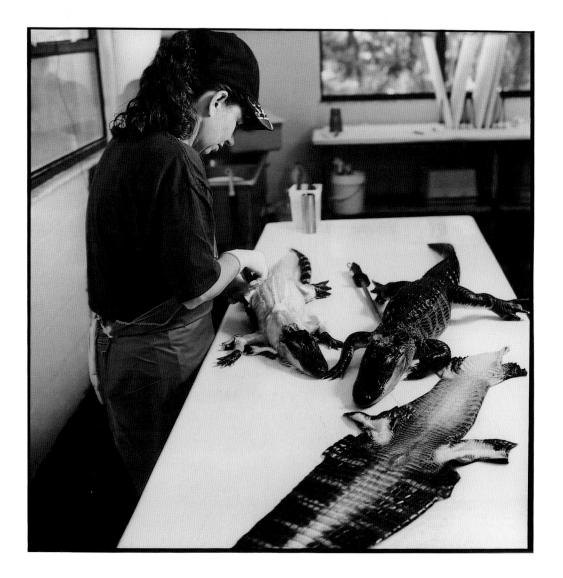

Jellyfish Farmer
Monterey, California

Todd Love is an expert when it comes to the lives and loves of jellyfish. Working in an innovative lab at the Monterey Bay Aquarium, he assists in the culture and development of these prehistoric creatures, from infancy to adulthood. Jellyfish come in a wide variety of shapes, sizes, and colors. Many are semitransparent and bell shaped. Maintained in water at about 60°F, they subsist on small, ocean-residing crustaceans called copepods or other jellyfish. They have a simple gut—which acts as gullet, stomach, and intestines—and a single opening that serves as both mouth and anus. With the exception of box jellies, jellyfish have no head, heart, eyes, or brains, which certainly simplifies their lives. So does the fact that some species of jellyfish reproduce asexually, but only in the polyp stage. Notwithstanding that their average lifespan is just a few years, jellyfish are the ultimate survivors, dating back some 600 million years.

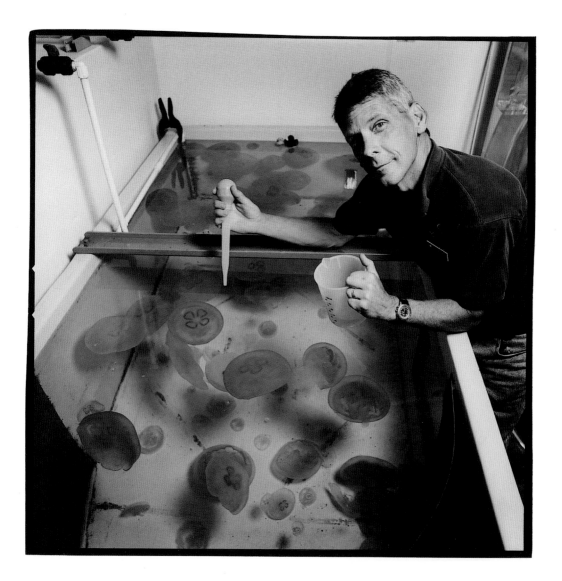

Lighthouse Keeper
Boston, Massachusetts

Located on Little Brewster Island at the entrance of Boston Harbor and dating back to 1716, Boston Light was the first lighthouse built in North America, and the last to be automated (not until 1998). Maintained by the Coast Guard, it is still active, with a twenty-four-hour-a-day flashing light and a fog signal. Sally Snowman has been the keeper since 2003. The first woman ever to hold the job, she is Boston Light's seventieth keeper and a walking encyclopedia of its history. Responsible for the facility's upkeep, Sally does more than oversee the lighthouse's historic preservation; she also conducts instructional tours—for some 3,500 visitors a year—dressed in a homemade colonial costume. Sally's love of the lighthouse predates her current paid post. She was smitten with this pre-Revolutionary War icon from childhood, was a volunteer on Little Brewster Island for nine years, and even chose to be married there.

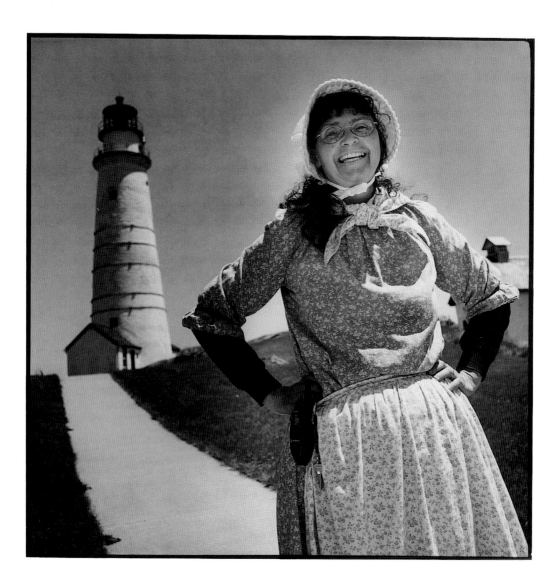

Ethnographers
East Hampton, New York

Husband-and-wife team Hy Mariampolski and Sharon Wolf have made curiosity about other people's habits pay off. Transitioning from an academic career in sociology in the late 1970s, Hy put his analytical skills to work improving consumer products and authored a text on the subject, *Ethnography for Marketers: A Guide to Consumer Immersion.* Sharon joined the business, QualiData Research, Inc., in 1987 after a career in corporate marketing. Now the couple spends their days inside people's homes observing how *Homo sapiens* perform such everyday tasks as cleaning their bathrooms, killing ants and cockroaches, taking showers, or barbecuing hot dogs. Recently, Hy and Sharon embarked on a cross-cultural study of laundry practices that took them into homes in Istanbul, Barcelona, and London. The key to their work is asking good questions and paying attention to responses as they spot people's frustrations when performing daily activities. Their aim is to come up with new or improved products that make life easier.

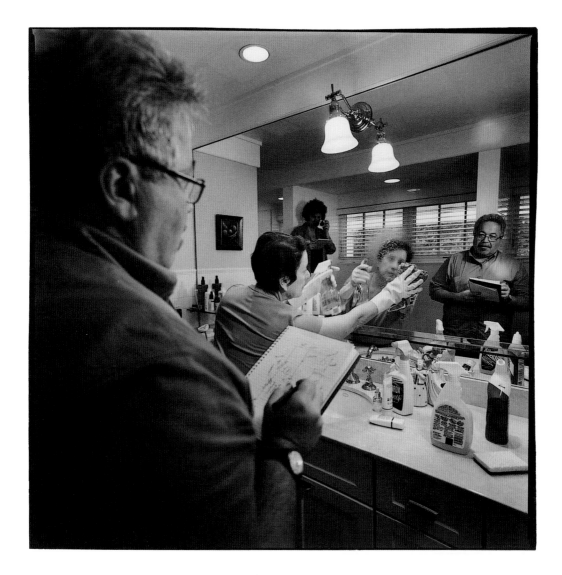

Palm Tree Trimmer
Los Angeles, California

Since becoming a Los Angeles transplant, Illinois native Dwayne Leftridge has scaled the heights. Not the movies, but palm trees have been his road to success. Leftridge learned his craft under the tutelage of a veteran tree trimmer in Arizona and quickly discovered a simple but compelling fact: with a few basic tools—tree-climber spikes, a lineman's safety belt, a chain, and his trusty palm tree knife—he could make a living any place in the world where palm trees flourish. There is, however, an element of seasonality to his work. Prime time for palm trimming, in Los Angeles at least, is from July through November when the seeds mature and begin to fall. That's when Leftridge takes to the treetops, removing dead fronds and skins or peeling the trees' trunks, while enjoying a bird's-eye view from as high as 120 feet. Life's good at the top.

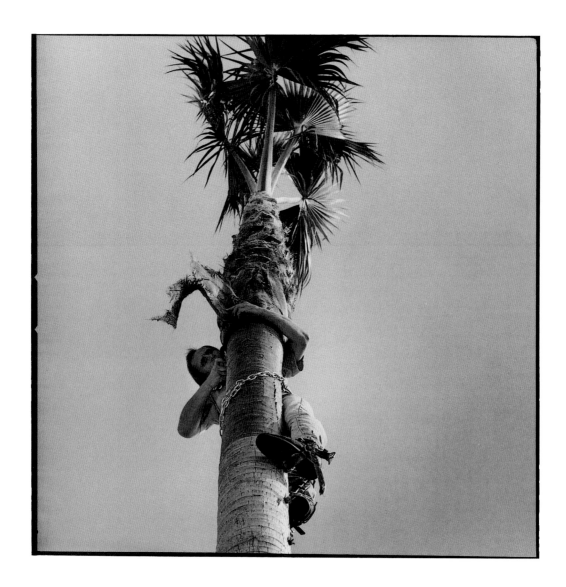

Hazardous Waste Cleanup Crew
Everett, Washington

Theresa Borst and Stacy Haney trained with the American Red Cross in 1998 to become emergency first responders. Switching to hazardous waste cleanup, they became certified as HAZWOPERS, taking forty hours of HAZMAT training. Well supplied with protective gear to keep them safe from infectious materials and hazardous waste, they are on call 24/7. At Bio-Clean, Inc., half of their time is spent cleaning up methamphetamine labs and another 25 percent is spent getting rid of mold, asbestos, rodents, and sewage. The "blood and guts" part of their operation—cleaning up after suicides, homicides, and accidents—consumes another quarter of their time. Their worst job ever? Dealing with the corpse of a heart attack victim who died in a hot tub and wasn't discovered for seven days. The medical examiner removed what was left of the body, leaving Theresa and Stacy with a pool skimmer to clean up the remains of the remains.

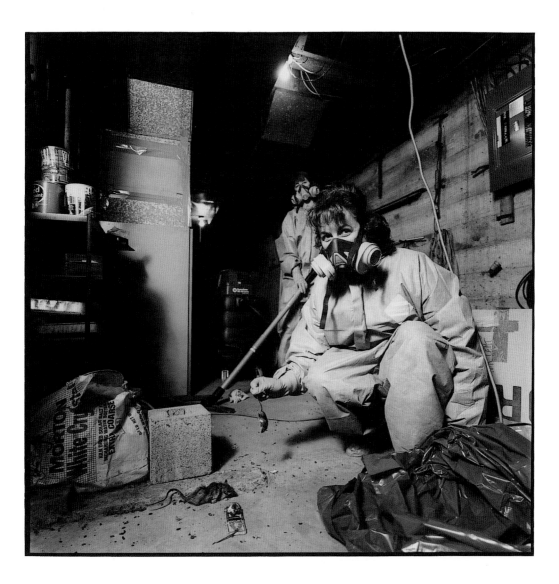

Horse Dentist
North Salem, New York

Russell Bateman's love of equines took him straight to the horse's mouth—particularly the mouths of show horses. He learned his craft the old-fashioned way, by apprenticing to another horse dentist. Now he has about 1,400 patients of his own. If the horse's mouth hurts, Bateman says, it can lead to neurological, skeletal, or muscular problems. But the loss of a tooth here and there isn't particularly worrisome as long as the horse can still masticate. Most of Bateman's work is preventive maintenance. He files down the sharp edges of the teeth so that the horse has a good bite and can eat well, and he changes the angle of the teeth to make the horse more comfortable in the bit. He also extracts "wolf teeth," extra little teeth above a horse's large molars, and an occasional decayed tooth. Contrary to popular belief, a horse's teeth don't actually grow as he ages. Instead, due to wear over the years, the horse's front teeth will angle out. That's why you can tell the approximate age of a horse from its front teeth, giving rise to the phrase "long in the tooth."

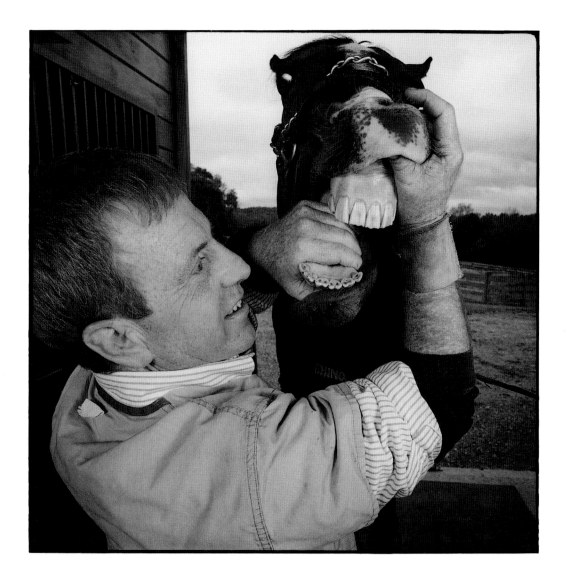

Competitive Eater
New York, New York

Eric Booker can't eat too fast, not if he's going to take home the bacon. As a competitive eater, he competes once or twice a month, simultaneously stuffing his purse and his belly. At an annual matzo ball eating contest, he pocketed the coveted $1,000 first prize by consuming thirty matzo balls in five minutes and twenty-five seconds—breaking his own previous record. Eric prepares for a contest by downing a gallon of water and eating nothing but cabbage and watermelon before the event. He's won other contests by gorging on fifteen burritos in eight minutes, forty-nine glazed doughnuts in eight minutes, eight and a half ounces of Maui onions in three minutes, and four and three-eighths pumpkin pies in twelve minutes. In 2005, the International Federation of Competitive Eating staged about one hundred feats of eats, spanning the food spectrum from lobsters to strawberries to corned beef hash. Partial to wieners, Eric particularly savors the competition sponsored by Nathan's hot dogs in Coney Island, where he last downed twenty-nine and a half dogs and buns in twelve minutes.

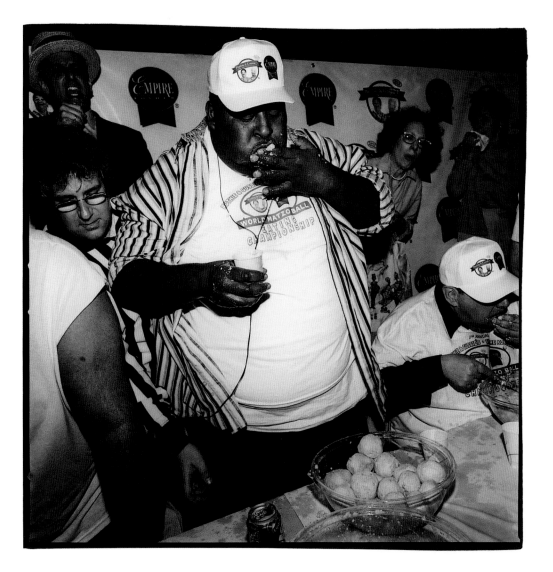

Mushroom Dealer
Scappoose Junction, Oregon

Under the guidance of his knowledgeable father, Lars Per Norgren picked his first morel at the age of seven. At twelve, he was foraging for meadow mushrooms, and by the 1980s he had graduated to full-time picker. An order one day for 800 pounds of chanterelles transformed him from picker to dealer. Although he still picks once a week, he now has about a hundred regular pickers who supply the 300-odd pounds he sells daily to Oregon restaurants. "Looking for mushrooms is a lot like going on a treasure hunt," he says. "You have to know what you're looking for and where to look." Lars is quick to share fungi-finding facts: for morels, search out a site where there's been a forest fire. For porcini, look near a grand fir in spring and under a Sitka spruce at the beach in autumn. Different mushrooms thrive on different hosts. While there are about twenty commercially available species of mushrooms in Oregon, worldwide there are hundreds of thousands, many as yet undiscovered. After more than twenty years on the hunt, Lars still enjoys tucking into mushrooms at dinner.

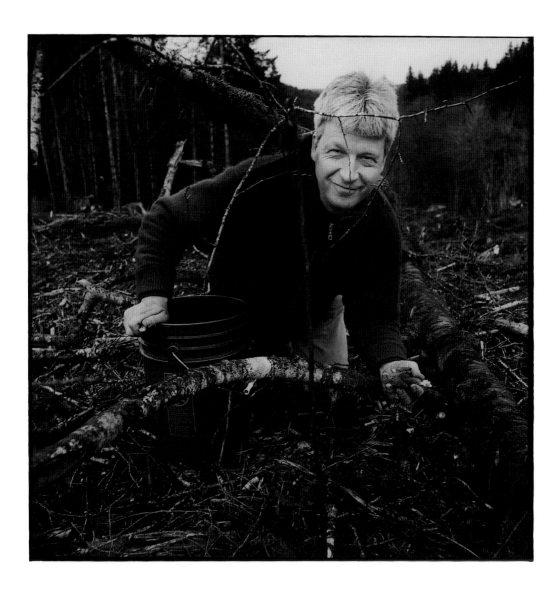

● Coroner's Gift Shop Sales Rep
Los Angeles, California

Skeletons in the Closet is the trinket shop of the Los Angeles County Coroner's Office in downtown L.A. The store grossed $271,923.72 in 2004. Sweatshirts, jackets, caps, briefcases, pens, key chains, mugs, mouse pads, lapel pins, silver car shades, welcome mats, beach towels, you name it—they're all emblazoned with a body outline and are for sale here. According to Salene Limon, the shop's sales rep for the past three years, the hottest item is a coroner's T-shirt. A coroner's windbreaker had to be discontinued because so many people wore it in attempts to enter crime scenes. Laugh if you will, but all this commercialism is for a good cause. The proceeds help support the Youthful Drunk Driving Visitation Program, an alternative sentencing option available through the L.A. county court system. The program focuses on the dire consequences of drunk driving, reminding us just how fragile life is. And who'd know better than the coroner's office?

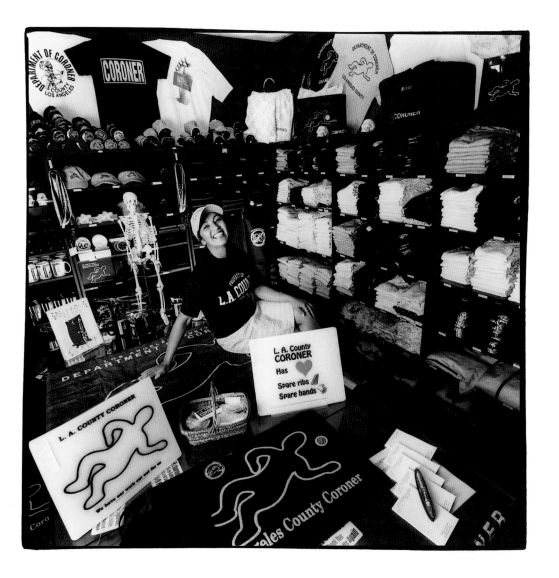

Falconer
Escondido, California

Although falconry is the world's oldest known sport, Thomas Stephan's falcons are bred for work. The mere glimpse of a falcon's heart-shaped silhouette or shadow is enough to send other birds packing. With top speeds of 242 miles per hour, the falcon has been called the world's fastest animal. In ninety seconds flat, it can swoop to the ground from a height of 15,000 feet. Thomas's falcons have been gainfully employed by the military in its Bird Air Strike Hazard abatement program, by airports to chase birds off airstrip runways, and by a Southern California vineyard that was plagued by European starlings. The use of falcons to drive off unwelcome birds is a low-tech, nontoxic, and highly effective means of pest control. The falcons don't kill birds; they just scare them silly. The downside to raising falcons stems from their migratory instincts; about one-third of Thomas's birds have flown the coop.

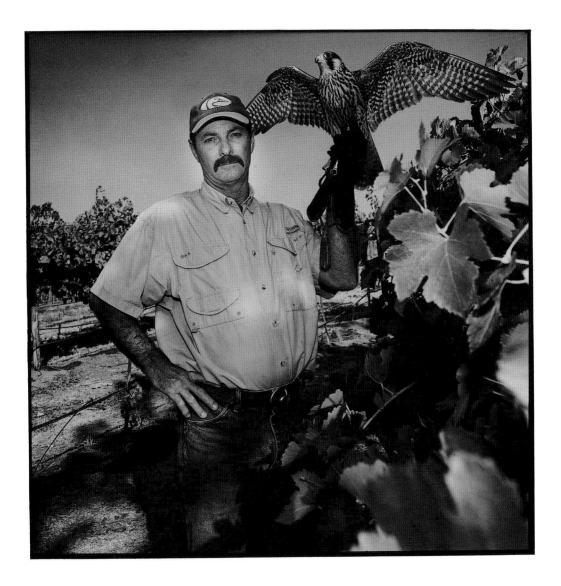

Waste Sorter
Peekskill, New York

Aaron Clough makes a strong case for the adage "Waste not, want not." Working for the Karta Corporation, a materials recovery facility, he daily faces a mountain of trash. But trash is in the eye of the beholder. At Karta, thousands of tons of trash form a stream of commercial waste every day as they pass through a series of sorting stations to be separated according to type and future use. Once sorted, the debris is recycled into new products such as mulch or road base material. At the cardboard and plastic sorting station where Clough works, one to two hundred tons of material are sorted and bundled daily to be shipped overseas for reuse. Nothing is considered garbage at Karta, and everything gets recycled and reused.

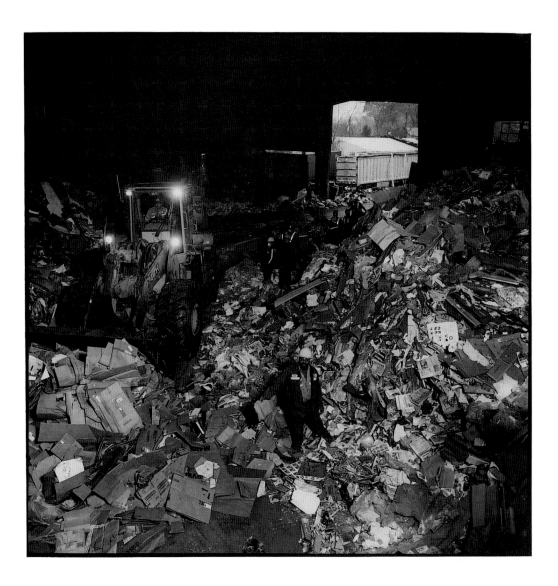

Paper Towel Sniffer
Manhattan, Kansas

Margo Fick has been putting her nose to work for the past fourteen years. As a veteran of the Sensory Analysis Center, she's sniffed her way through women's perfumes, men's colognes, deodorizing products, shampoos, and a host of cooking smells. These days, paper towels are her specialty. Because nobody likes their paper towels to have a smell of their own, paper towel manufacturers go to great lengths to ensure an odorless product before, during, and after use. Margo's task is to make certain that once a paper towel is used—say, to mop up a spill—no offending paper towel odor is detectable. Forget high-tech instruments: a brandy snifter is her preferred device for sniffing out the essence, or lack thereof, of a soggy paper towel. To keep her nostrils at peak performance, Margo herself must be scentless on the job. That means no perfume or hairspray and a sterile lab coat, and please, don't even dream of sending her flowers at work.

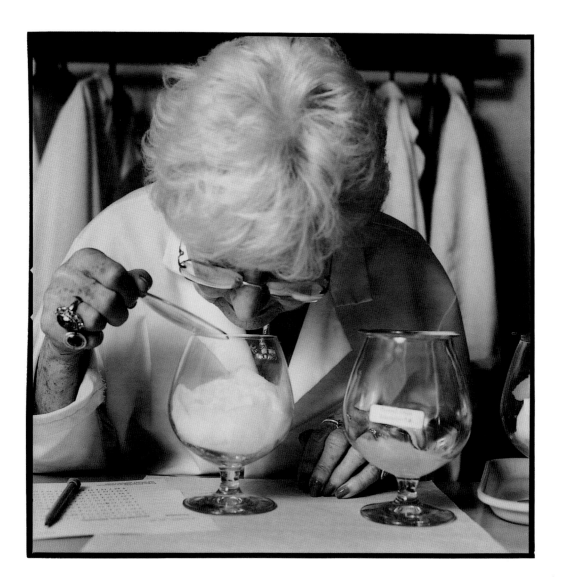

Ribbon Candy Puller
Denver, Colorado

Working for eighty-five-year-old Hammond's Candies on the outskirts of Denver, Ouane Chareunsock has a lot of pull with his employer. In fact, pulling is what Ouane does most. While Hammond's Candies produces hundreds of types of candies, among them chocolates, it's their candy canes, twisted lollipops, and ribbon candies that take the most muscle to make. Producing ribbon candy is a labor-intensive process: hefty batches of sugar, corn syrup, water, and coloring agent are combined and heated in copper kettles. After reaching the desired consistency, the substance is cooled briefly on a steel slab. Then batches of red, white, and green are laid side by side; this is where Ouane comes in. He pulls and pulls and then pulls some more until the sweet stuff is thinned down to about an inch wide. The final product is a red, white, and green ribbon that would be perfect for wrapping Christmas presents if it weren't hard and made of sugar.

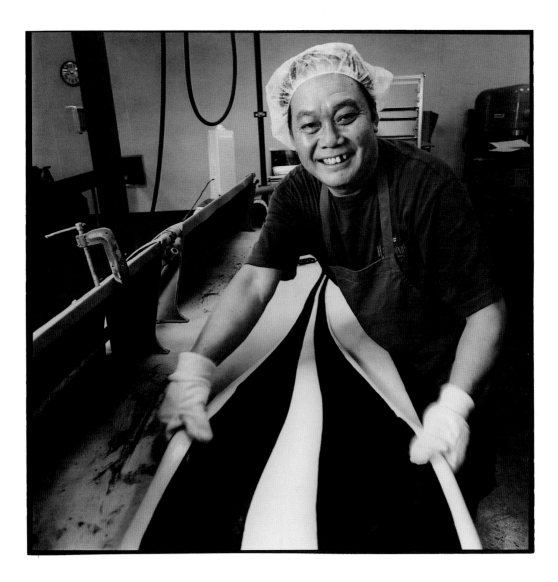

Sandcastle Building Teacher
South Padre Island, Texas

Some people build castles in the sky. Lucinda Wierenga, aka Sandy Feet, builds them in the sand. Formerly a high school English teacher, Lucinda drifted into her present career by participating in sandcastle-building contests. But teaching was in her blood, and soon she was demonstrating her expertise at conventions and workshops and ultimately in private lessons. In two-hour sessions, she teaches how to hand-stack towers, walls, and arches, as well as the art of combining them. Then with an array of tools that she makes herself, she demonstrates her forte—carving. Some sand is better than other sand for making sandcastles, and Lucinda is lucky to live two blocks from a beach where the sand is excellent. Silt deposited by the Mississippi River gives the sand of South Padre Island, in the Gulf of Mexico, an ideal stickiness and clay content. Does she mind when the tide comes in and washes away her creations? No, she insists, the ephemeral nature of sandcastles is part of their charm.

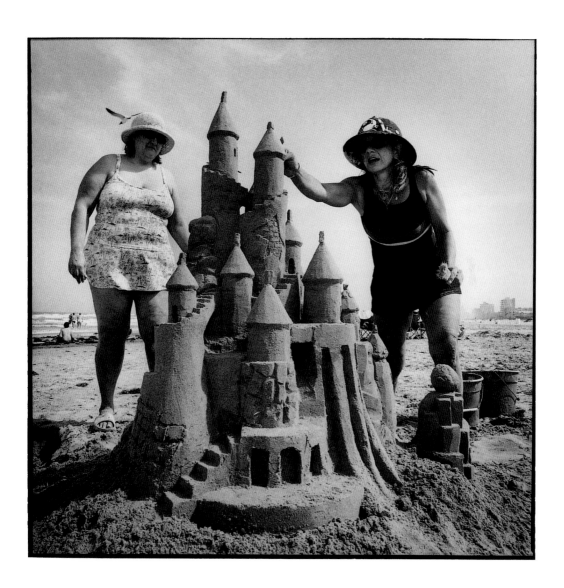

Hollywood Boulevard Star Shiner
Hollywood, California

John Peterson is the official star polisher on Hollywood Boulevard. A plastic bag filled with rags and cleaning agents in tow, John, who is one-legged, navigates his workplace on crutches. He makes an endless circuit up one side of the famous boulevard and down the other between La Brea and Gower Avenues, polishing an ever-growing galaxy of stars. At last reckoning, there were 2,207 stars, but more are added all the time. John originally took up polishing more than ten years ago as a means of earning spare change. But when the director of the Hollywood Entertainment District caught sight of the resultant gleam, the job was made official. Now John holds a salaried position with benefits, and some twelve million tourists a year can wish upon the shiny stars along Hollywood Boulevard.

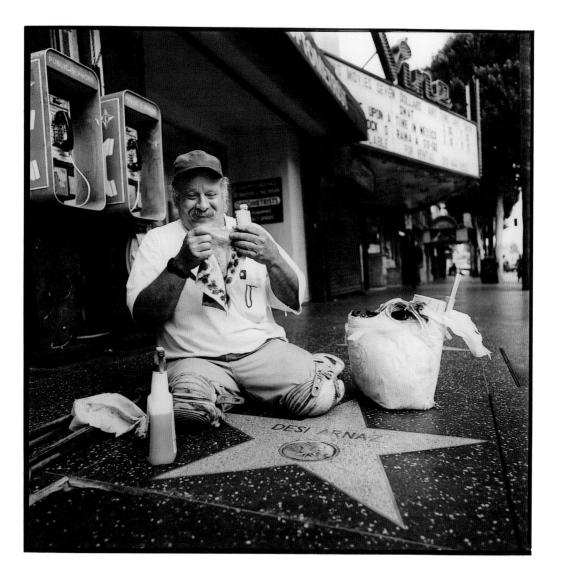

Shepherd
Pleasantville, New York

James Eyring has been shepherding on Pace University's two hundred acres for twenty-four years. He serves as assistant director at the university's Environmental Center and keeps a flock of sheep to provide a job for two resident border collies, Abbey and Dell. The working dogs were originally brought in seven years ago to chase off Canadian geese, whose habit it was to defecate all over campus. So effective were the dogs that the geese flew the coop; now the sheep keep the dogs in shape. Saying "Come by," "Away to me," and "Here to me," Eyring signals the dogs as they circle a flock comprising two dark sheep from Barbados, four white ones from St. Croix, and a tagalong American Alpine goat. Eyring claims that his shepherding is a labor of love, part hobby and part work. In his spare time, he's a gardener, a falconer, and a menagerie keeper as well.

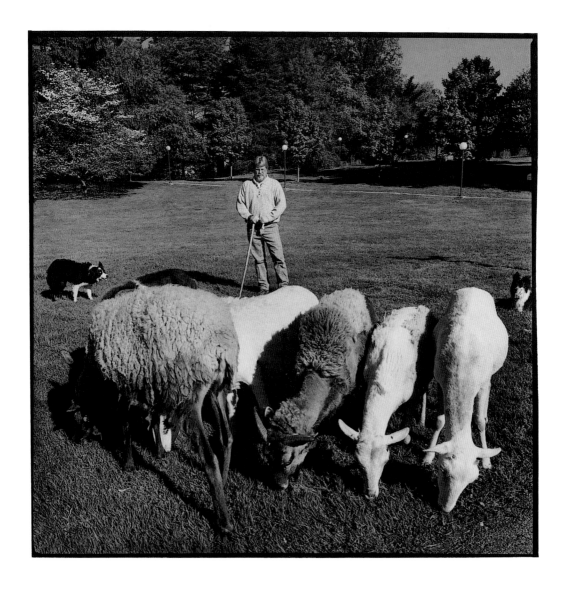

Professional Whistler
New York, New York

No one has to tell Steve Herbst to whistle while he works. Steve quit his day job in 2004 and became a professional whistler. He began tuning up his lips at age seven, by ten he had mastered Prokofiev, and soon thereafter he was imitating oboes and flutes while also developing a three-octave range. In 1994, he attended his first competition—an annual whistlethon in Louisburg, North Carolina—and came in fifth. Two years later he placed second, in 2002 he won the International Grand Championship, and for three years straight he took the title Best International Whistling Entertainer of the Year. Whistling everything from classical to jazz, blues, R&B, standards, operatic arias, and show tunes, Steve has puckered up at the Kennedy Center, Carnegie Hall, and Harlem's famed Cotton Club. Transcending language barriers, he has done TV commercials for the Asian as well as the American market. Steve dreams of a revival of the Golden Age of whistling—the 1930s through the 1950s—and of having his own chair in an orchestra.

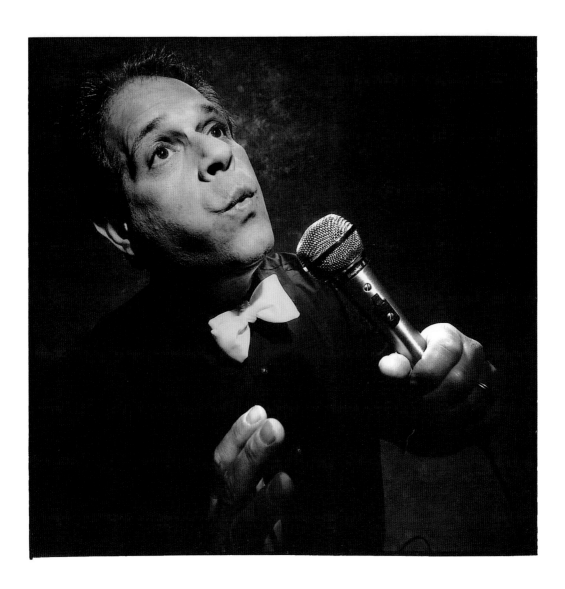

Owl Pellet Cleaner
Bellingham, Washington

As a college student interested in birds of prey, Bret Gaussoin was out one day looking for hawk nests when he happened upon some owl pellets. He took them to one of his professors, who happily handed him a check and sent him out for more. Professor Irwin Slesnick had started a business that supplies owl pellets to classrooms for educational use. Bret bought the operation in 1993 and soon doubled its size. Barn owls forage all night and generally swallow their prey whole. Eight hours later, back at the roost, they regurgitate the bones intact, producing a pellet perfect for dissection and skeleton reconstruction. While Bret no longer collects the pellets himself, a hundred West Coast collectors supply him with bucketsful. He readies the pellets for shipment by baking them and then wrapping them in foil. They are sent out—about half a million pellets a year—to fifteen thousand schools, Scout troops, 4-H clubs, and environmental centers throughout the United States and Canada. Now that's recycling.

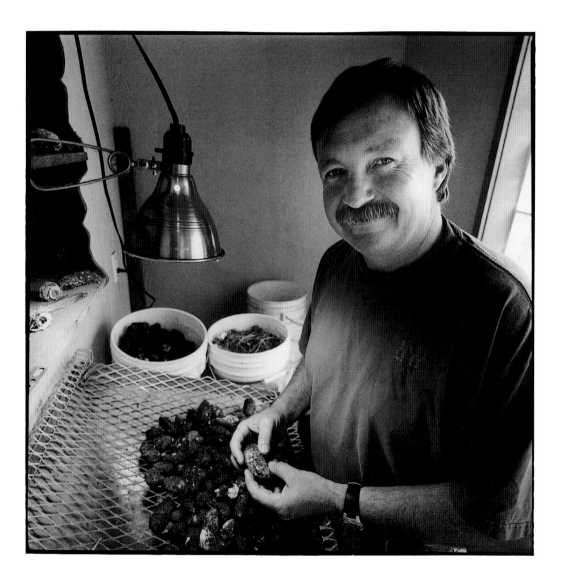

Ball Tester
Springfield, Massachusetts

Joseph Gebski has a hands-on job at the Spalding Ball Company. Every basketball that Spalding supplies to the NBA—and they have the distinction of providing *all* the balls used in NBA games—passes through his hands. A thirty-five-year Spalding veteran, Joseph does quality control, weeding out any flaws before the balls hit the boards. First he subjects the balls to an air-retention test, inflating them and leaving them overnight to check their holding power. Then he scrutinizes them for roundness, weight, and reboundability. From a height of 72 inches, each ball must rebound between 50 and 53 inches. Although Spalding makes footballs, volleyballs, soccer balls, and softballs, their basketballs give them the biggest bounce for the buck: they sell some four million of them annually.

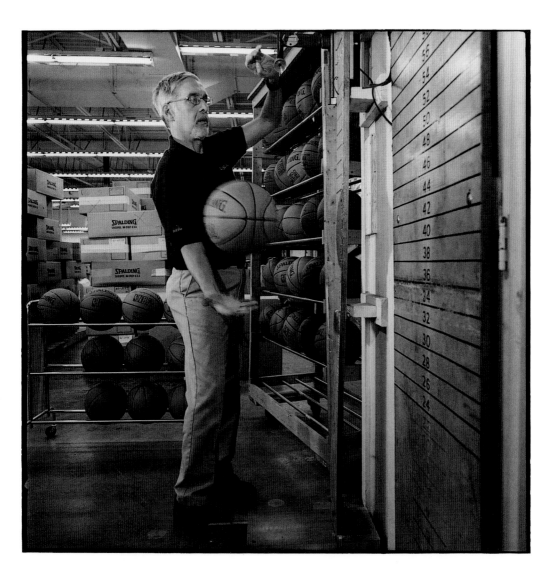

Music Thanatologist
Salt Lake City, Utah

Having studied and worked as a musician for forty-three years, C. Tristan Adair moved on to specialize in music thanatology at the Chalice of Repose Project in Missoula, Montana. *Thanatology* derives from the Greek word *thanos*, which means death. Now working at CareSource Home Health and Hospice, Tristan plays her harp at the bedside of the dying to relieve their physical and spiritual anguish and that of their loved ones. To date she's given solace at about two thousand vigils. Her musical prescription differs for each patient, from Celtic lullabies to Gregorian chants. Playing the harp, and using her voice as well, Tristan synchronizes her music with the patients' breathing, thus easing them peacefully into their eternal sleep.

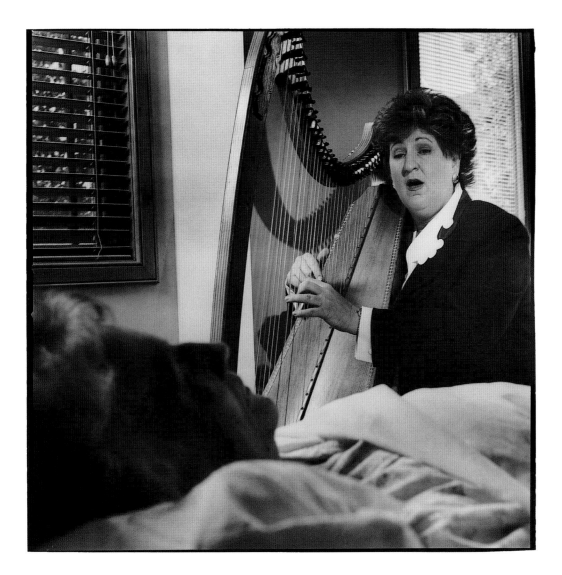

Nuclear Power Plant Night Watchman
Rainier, Oregon

Paul Rose has been a watchman at the Trojan Nuclear Plant for the past fourteen years. He was on the job when the plant was running, and he is there now during its decommissioning. Not everyone would be as sanguine as he is about daily proximity to spent fuel, but Paul boasts that he has yet to receive even 50 millirems of radiation, or 1/100 the yearly limit. His official title—Independent Spent Fuel Storage Industry Specialist—has the acronym ISFSI Specialist, which he jokingly translates as Ingenious Solutions for Sustained Income Specialist. Working the graveyard shift affords Paul lots of peace and quiet and even some leisure time. When he's not touring the facility—checking that all doors are locked and lights are on, surveying the cooling tower, or doing mountains of data entry—his greatest on-the-job pleasure is watching the sunrise each morning.

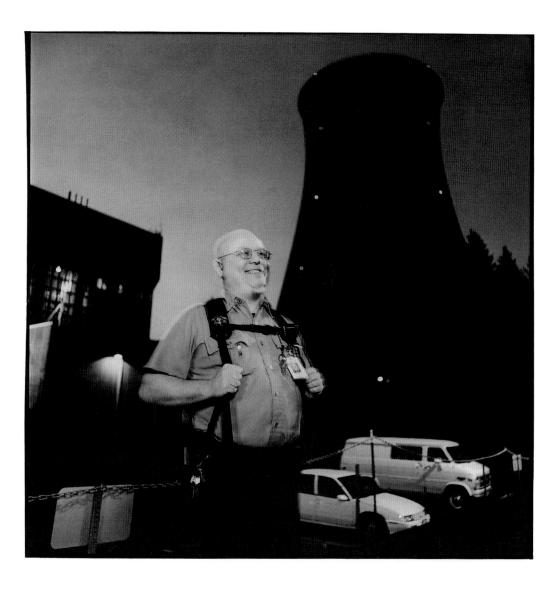

Vintage Toaster Dealer
New York, New York

Michael Sheafe has floppers, swingers, pop-ups, pinchers, sliders, walkers, and twirlers among the four hundred or so vintage toasters he's got for sale. When he left his job as a project manager for American Express six years ago, Sheafe considered the admiration often bestowed upon his old Sunbeam. Aware that he could find old toasters for about five bucks a pop, he set out to collect them at estate sales, swap meets, and sundry places. Although he looks for clean, working models that don't need repairs, he's also taught himself to make necessary fixes. Most of the toasters just need a bit of TLC and elbow grease. In addition to selling at local flea markets, Sheafe sells online worldwide (the American Embassy in Beijing and the Canadian Consulate in Mexico each have one), has rented toasters as props for window displays and Broadway plays, and has exhibited prized examples at museums and galleries. The average price of his functional antiques runs between one and two hundred bucks, but a spectacular Universal from the 1920s is his priciest item at $1,450. You've got to admit, that's a fair amount of bread.

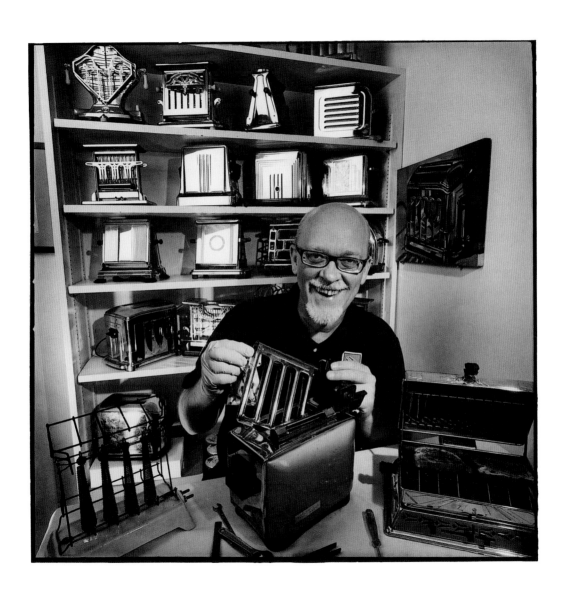

Taxidermist
Cocoa, Florida

In a small hideout behind her house, Lori Richterkraft takes the heads of all kinds of animals and makes her own type of art—taxidermy. She prefers to work on larger animals, such as a warthog from Africa, rather than on smaller ones like a squirrel. Lori has been mounting heads for seven years and learned by apprenticing and experience. She uses reference pictures, and the tools of her trade include hacksaws, plastic forms, epoxy glue, needles and thread, airbrushes, and paint. The hardest part of her job is fixing up a head that is in bad shape, such as having big holes from gunshot. Being a hunter herself, she knows the importance of a good shot.

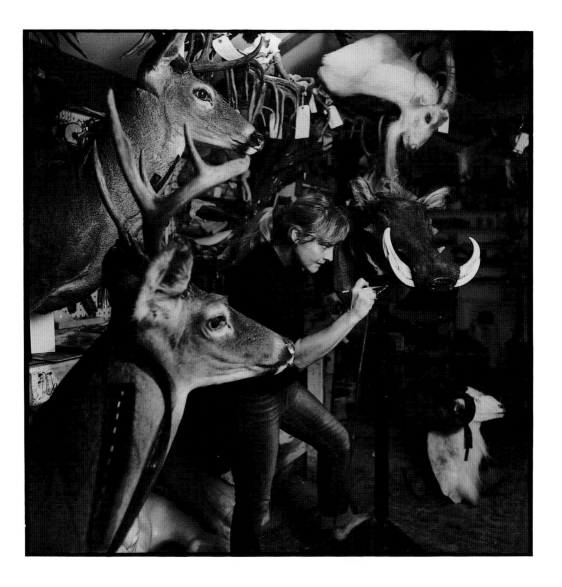

Dowser
Abiquiu, New Mexico

If there really were water, water everywhere, Bryan Lappe would be up the creek. Sixty percent of his dowsing jobs entail a search for water. He first learned to dowse at his grandfather's knee as a lad of ten, but it wasn't until midlife that Lappe took up dowsing seriously. Like witching or divining, dowsing has a spiritual and intuitive component. Lappe believes that a dowser takes his cue from his adrenal glands and that the fuller his bladder, the more he can "see." Before undertaking a dowsing, he always asks Mother Earth and the higher powers for permission to find water. A negative answer pulls the plug on a project. But if the response is positive, he sets to work. Holding a plumb bob pendulum over a map of the property, Lappe asks a series of "yes" and "no" questions and watches the pendulum's movements in response to them. Having narrowed down the search area, he then walks the actual hot spot while holding two bent brass welding rods. The rods' movements tell him exactly where water is. Then a straight rod reveals the water's depth. His success rate? More than 90 percent!

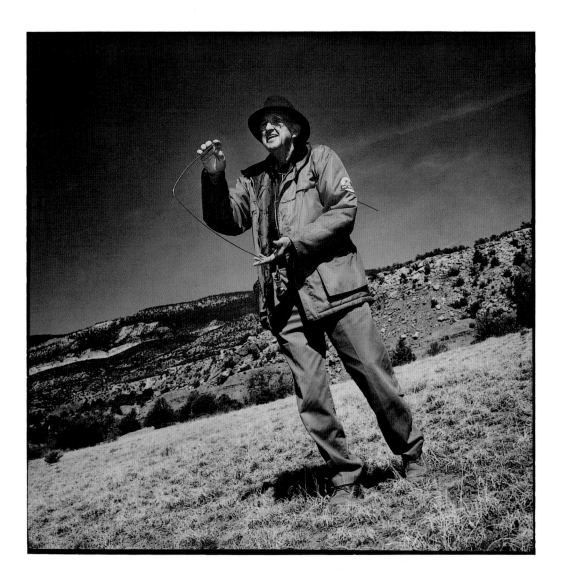

Carillonist
Berkeley, California

Thanks to carillonist Jeff Davis, the UC Berkeley campus is alive with the sound of music, morning, noon, and night. Carillons aren't standardized; they vary in the number and size of their bells. Berkeley's, for example, is a massive instrument with sixty-one bells, the lightest weighing 19 pounds and the heaviest weighing 10,500 pounds. As the university's head carillonist, Davis not only keeps the campus resounding, but he also teaches the instrument and composes for it. Like an organ but much larger, the instrument is played by pushing batons that are linked by wires to the clappers of the bells, which are positioned above him. Fancy footwork on pedal keys activates the larger bells. Who takes up the carillon? According to Davis, it has to be someone with a powerful case of "bell fever." He himself caught it twenty-one years ago.

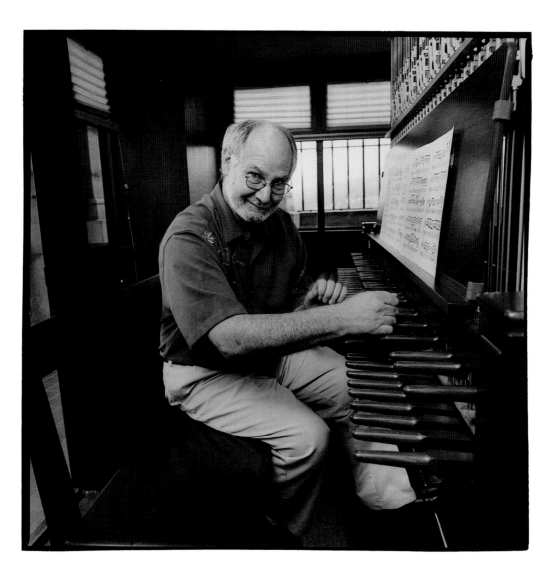

Smell Research Technician
Philadelphia, Pennsylvania

Chris Maute doesn't mean to get personal, but it's his job to find out just how people smell. As a smell research technician at the Monell Chemical Senses Center, he gets involved in all aspects of their sensory testing experiments, from recruiting subjects to inventing testing gear to performing the tests that show how people smell and what their bodies and brains do with the information. For example, this device measures blood flow and swelling in the nose and establishes a baseline against which to measure the effects of chemical irritants such as ethanol, acetone, or histamines. Different subjects have different sensitivity to odors, and personality variables affect their sense of smell. Smells influence heart rate, breathing, skin conductivity, and startle responses. These factors are all relevant to any company selling a product with a fragrance, whose bottom line depends on buying and smelling.

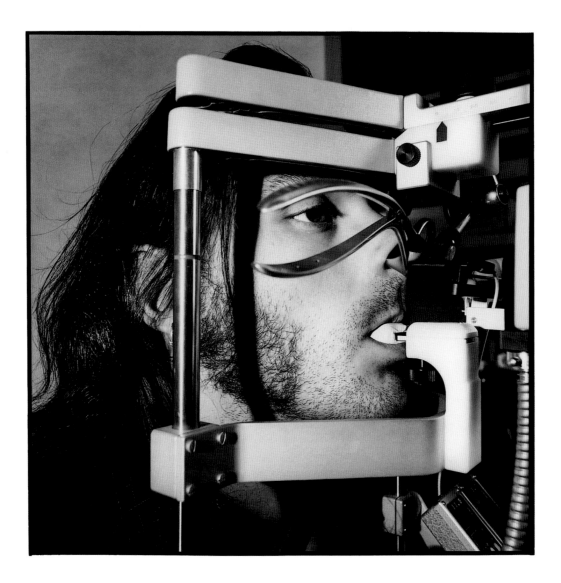

Snow Maker
Coral Gables, Florida

Dan Hendler doesn't mind a good snow job. In fact, he depends on it. Working for the Palm City Ice Company in sultry Coral Gables, Florida, it's his job to do what Mother Nature doesn't. Since it never snows in southern Florida, snow makers are often hired to fill the breach. Mountains of snow are a popular attraction at elementary schools, shopping centers, zoos, and even private parties. The Palm City Ice Company, run by a transplanted New Yorker, fills about 140 orders a year between November and February, not to mention the occasional snowstorm in July. The average snow job takes about twelve tons of ice, which is put through an ice slinger mounted on a truck. The cost is about $150 to $200 a ton, and it takes about fifteen minutes. Melting is left to the elements.

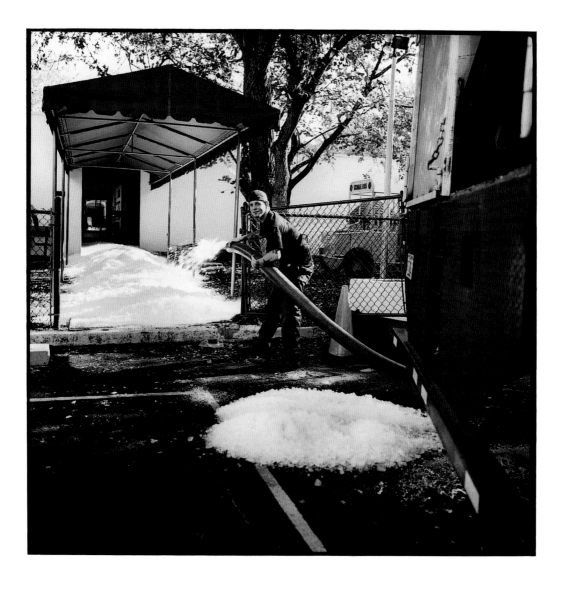

Statue of Liberty
New York, New York

Not every woman goes for the tarnished look. But Jennifer Stewart, Living Liberty, isn't every woman. An idle remark lit her fire. Told she resembled the Statue of Liberty, she entered the 1986 National Statue of Liberty Centennial Look-Alike Contest—one of more than a thousand entrants—and took home the title. She's been carrying the torch ever since. A homemade costume and hand-mixed, water-based, theatrical makeup give her the heavy-metal look. While Mom still urges her to get a "real" job, Jennifer has been earning her keep as the Statue of Liberty for nineteen years, traveling on her clients' dime to Japan, Singapore, Brazil, Monte Carlo, London, and Mexico. She's the toast of conventions and trade shows, has been a highlight at NYU's graduation ceremony for the past six years, and is an annual star at the Liberty Mutual Insurance Company's Legends of Golf Tournament, to say nothing of ad campaigns and an appearance with Tom Hanks in *Joe Versus the Volcano*. When Jennifer strikes her classic pose, which she can hold for up to twenty minutes, strangers flock to be photographed with her. The occasional true believer has even knocked on her to test her metal.

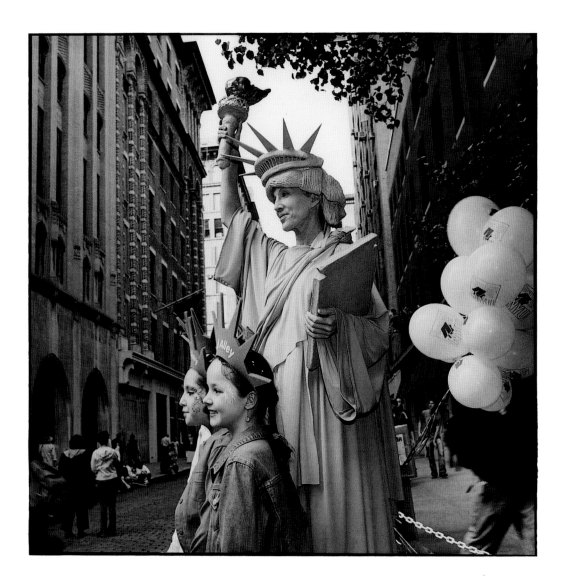

Gum Buster
Washington, D.C.

Duane Cummins isn't a gumshoe. In fact, gummy shoes are his nemesis.
Having started out in the dry cleaning business, he traded random spots
for gum removal five years ago. Now customers abound, particularly those
who run tourist attractions, train stations, courthouses, and universities. He
charges by the square foot and by how much gum infects the area. To date his
biggest job was a bus station in Maryland that took three weeks to degum.
Duane's secret weapon is an environmentally safe gum cart engineered to
produce hot steam with little pressure. It heats the gum to 300°F, using
96 percent dry steam mixed with a special cleaning agent that dissolves
the gum. Duane has four of these devices, as well as a generator, and two
employees. Typically the sticky season lasts from March through December.

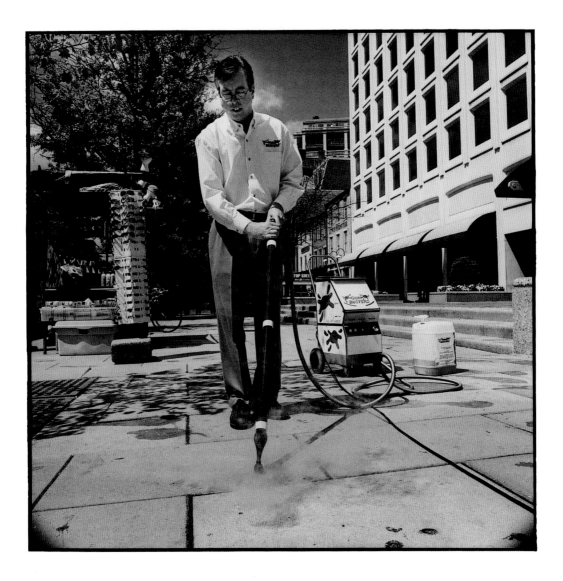

Urban Beekeeper
New York, New York

Between tending seventeen beehives scattered around Manhattan rooftops and selling honey at Greenmarket Farmers Markets in the city, David Graves is as busy as one of his bees. In 1997, he decided to move his hives to the Big Apple from his farm in Massachusetts because he was facing big competition for his honey from neighboring black bears. Now a major part of his business involves trucking supers, the wooden boxes containing frames laden with honey, back to the farm. He then removes the honey from the combs using a hand-cranked extractor. Each of David's hives is home to approximately fifty thousand bees, whose labors produce between 80 and 140 pounds of honey per season. There are generally three harvests from spring to October. Since the flavor of honey depends on the flora that the bees visit, different parts of Manhattan yield different honey essences. Upper West Side honey has a flowery taste due to a plethora of locust trees, whereas honey from the Lower East Side, where linden trees are common, has a minty tang.

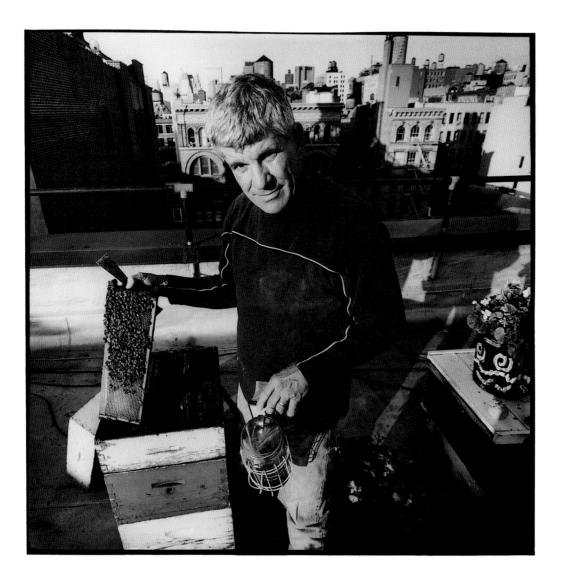

Rooftop Lawn Mower
Snowbird, Utah

Blanketed by some 500 inches of snow annually, Snowbird, Utah, is Christmas-card perfect for much of the year. Yet come summer, the rooftops on its ski resort lodges are transformed from snowy white to grassy green. Not only do these rooftop lawns provide startling aerial views for passing birds and airplanes, but they also serve an ecological purpose, helping to slow down and absorb the melting snow. Like any lawn, these verdant rooftops must be mowed and weeded—which is where Dave Tyler comes in. His ministrations keep the rooftop lawns as tidy as any golfing green. But with winter's return, don't be surprised to find Dave on the ski slopes. That's a definite perk of working in Snowbird.

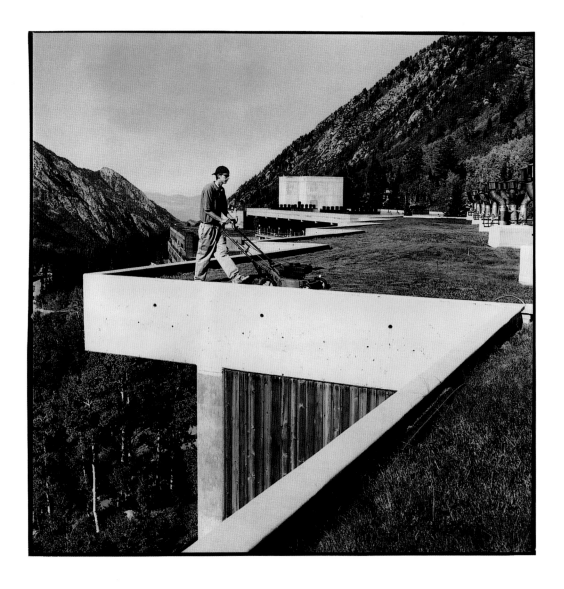

Bird-Watcher
Santa Fe County, New Mexico

Whether there is a murder of ravens, a covey of quail, a gaggle of geese, a congregation of plovers, or an exultation of larks to be sighted, the ubiquitous Lawry Sager is at the ready with his binoculars. He figures he can identify more than half of the eight hundred bird species in North America. His bird-watching days began when he was a child of six, and he's had his eyes peeled for them ever since. Not only a bird-watcher, Lawry is also a bird counter, and he's counted for such conservation- and environment-sensitive agencies as the New Mexico Department of Game and Fish, U.S. Fish and Wildlife Service, Bureau of Land Management, and some private organizations. Hawkwatch International hired him as a hawk-watcher during a fall migration, and he spent a year scouring New Mexico for mountain plover. Currently he's conducting a survey of the reproductive success of the burrowing owl for the Rocky Mountain Bird Observatory. Although Lawry is as happy as a lark counting his feathered friends, sadly his numbers often reveal that they are diminishing in quantity.

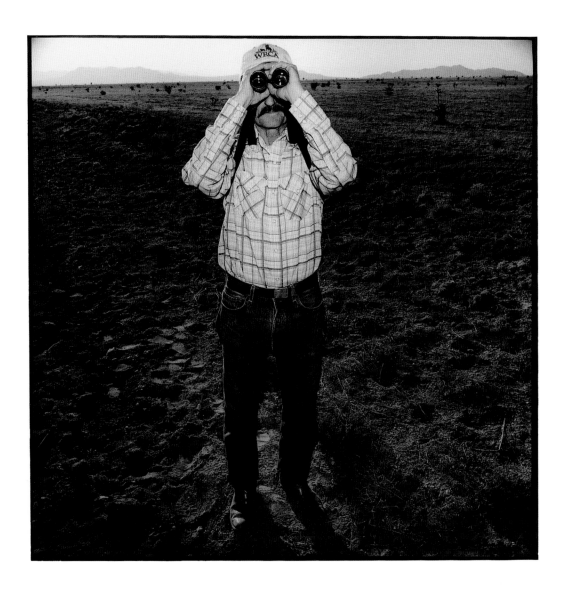

Flatulence Smell-Reduction Underwear Inventor
Pueblo, Colorado

They say that necessity is the mother of invention, and that certainly holds true for Buck Weimar, inventor of Under-Ease underwear, made for protection against bad human gas (malodorous flatus). Inspired by his wife, who suffers from Crohn's disease, a gastrointestinal disorder, he was moved to come up with a remedy for hydrogen sulfide gases, the primary culprit in foul smell. After six years of experimentation with different filters and underwear materials, he launched his business in 2001. The latest sales report for 2003 was fifteen thousand pairs sold worldwide. Buck works from his basement office, and 97 percent of his business is done over the internet. Although there are the occasional gag purchases, his product sells well, helps many sufferers, and has the smell of success written all over it.

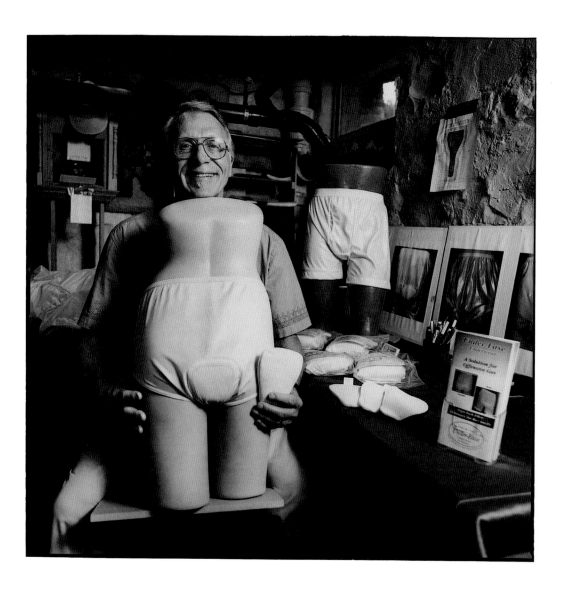

Acknowledgments

Once again I'd like to express my deepest gratitude to Joanne Jaffe, my dear friend who has helped me in every aspect of this endeavor. She is my first editor, my unbiased critic, and my unwavering confidence builder. I love my publisher, Phil Wood, who has become my dear friend as well. Todd Heughens and Joyce Rudolph have added their talents as artistically as with the first book. My closest friends, Cheryl Wiesenfeld, Gayle Sand, Karen Abrams, Joy Nagy, and Sharon Oddson, and my mom, have always stood by me lending their support, confidence, and even some physical muscle. Holly Taines White, Lisa Regul, Erika Bradfield, and Annie Nelson at Ten Speed Press have my deepest appreciation for creating a wonderful publishing experience, which I am sure contributed greatly to the success of the first book, *Odd Jobs*.

There have been so many others who have given odd job suggestions, hosted me in their homes, and in one way or another facilitated my efforts. Thanks to my brother, Alan Schiff, and to Peter Fodera and Ken Needleman, my cherished neighbors, and friends new and old with some relatives thrown in: Joyce and Alan Rudolph, Cherry and Doug duMas, Deanne Bellinoff, Marc Friedland, Carl Kravats, Martha and David Osler, Karen Schiff, Stephanie and David Schulhofer,

Ellen and Harvey Friedman, my aunt, Gloria Weinberg, Joyce and Steve Mathias, Michael Lasky, Brent Sterling Nemetz, Denise Abrams and Dave Harrington, Libby Stuber and Ed Pomponi, Amanda Montgomery and Rick Von Kaenel, Ellyn Anne and Hank Geisel, David Cohen and Cheryl Stevens, Stephanie Reit, Roger Hines, Candida Royalle, Kathy and Lou Jacobs, Ken Schuler, Joan Husman, Michael and Michi Raab, Jennifer Fields, Elizabeth Chen, Erika McCarthy, Remy Jewell, Darlene Carter, Ron Blum, Sharon Grollman, Bill Robb, Martha Wagner, John Rossheim, Buck Wolf, Bruce Handelman, Tony Bonzanino, Dan Mork, Edgar Chambers, Tricia Baressi, Leslie Stein, Lauren Ostrow, Ken Peterson, Don Henderson, Tama Starr, Traci Jenkins, and Dave Fields.

And thank you to all the people who bought the first book, *Odd Jobs, Portraits of Unusual Occupations.* You were the wind beneath my sails.

Index

The End